Front Page
Photo Puzzles

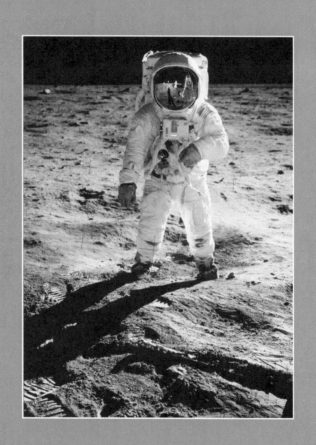

Front Page
Photo Puzzles

Famous Photographs Altered for Your Amusement

By Hal Buell

BLACK DOG
& LEVENTHAL
PUBLISHERS
NEW YORK

Copyright © 2009 Black Dog & Leventhal Publishers

Published by
Black Dog & Leventhal Publishers, Inc.
151 West 19th Street
New York, NY 10011

Distributed by
Workman Publishing Company
225 Varick Street
New York, NY 10014

Manufactured in the United States

Cover design by Sheila Hart Design Inc.

Interior Design by Liz Trovato

ISBN-13: 978-1-57912-819-7

h g f e d c b a

Library of Congress Cataloging-in-Publication Data

Introduction

The pictures in this book capture telling moments from the distant and the not-so-distant past. Many of the photos are famous, others less so. All appeared in newspapers, magazines and books. Some bumped history or informed us of events great and small. Others recollect a long ago smile or a nostalgic reminder of a special time and place. Details in the photos, like a once abandoned but newly rediscovered notebook, revive memories of forgotten crises and pleasures. As you explore each picture, you might even get a new insight to news events of yesteryear and yesterday.

Where appropriate captions offer a bit of history connected to the photo, the captions also tell how many changes were made. That is where the puzzle comes in.

To create these puzzles we have taken liberties with the photos by changing them in different ways. Each alteration offers a challenge to the beholder: find the differences or the twists that make the altered photo different than the original.

There are three kinds of puzzles.

In "**Find the Changes**," there are two versions of a picture. One reproduction shows the photo they way it originally appeared. The second is altered in small ways and big ways. The viewer must find the differences.

In "**Which is Different?**" we offer four reproductions of a photo. One of the four is different than the other three. The challenge: find the photo that is slightly different.

In "**What's Wrong?**," we reproduce a famous picture that has been altered and the reader must determine the error we have entered in the picture.

Solutions for every puzzle are found in the back of the book.

In the real world of news photography it is a serious matter to alter pictures. But our digital manipulators—Nick Clough and Claudia DiMartino—have taken a lighter view to make puzzles that will keep readers searching for elusive alterations. They would never change daily pictures in the media, but every once in a while you have to have a little fun.

Go to it, picture detectives!

—Hal Buell

Editor, *Front Page Photo Puzzles*

2009

Barack Obama, the first black president of the United States, delivers his inaugural speech on a chilly day in Washington, DC. Tens of thousands attended the historic January 2009 proceedings. But there is something odd about this picture. Find it if you can.

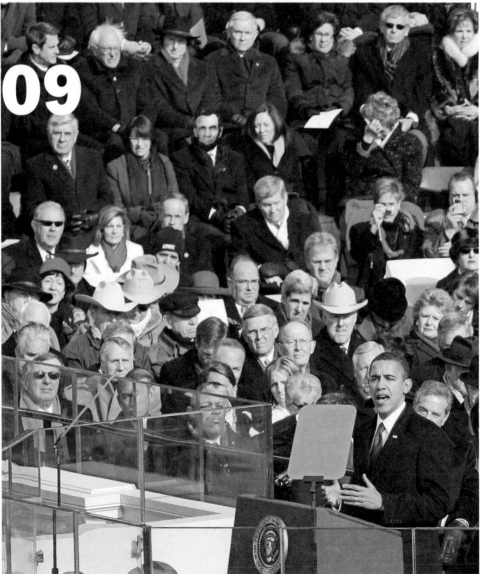

What's wrong? see page 103

1945

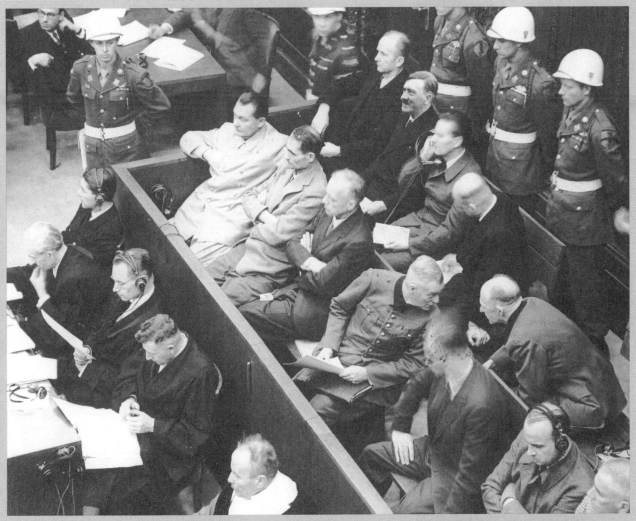

Nazi officials, accused of war crimes in World War II, stand trial at the Palace of Justice in **Nuremberg** in 1945. American military police guard the lengthy proceedings. But there is a strange twist to the picture.

1981

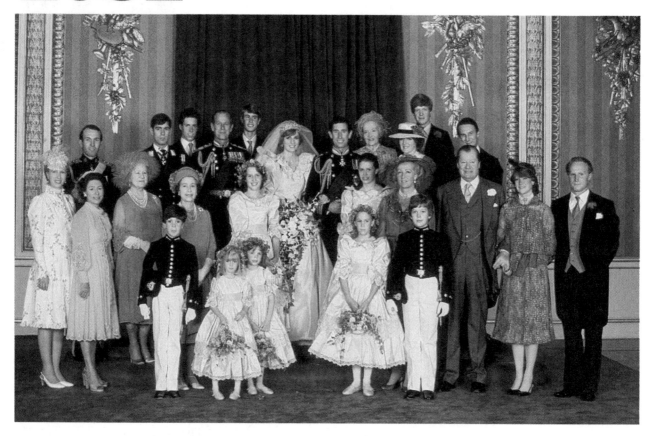

The big British Royals story of 1981 was the long-awaited marriage of **Prince Charles**, heir to the British throne, to **Diana Spencer**, who became the Princess of Wales. The happy couple poses here for the official wedding photo. The English loved Diana, but the marriage to the prince failed and ended in divorce. Diana later died in an auto crash in Paris and the Prince remarried.

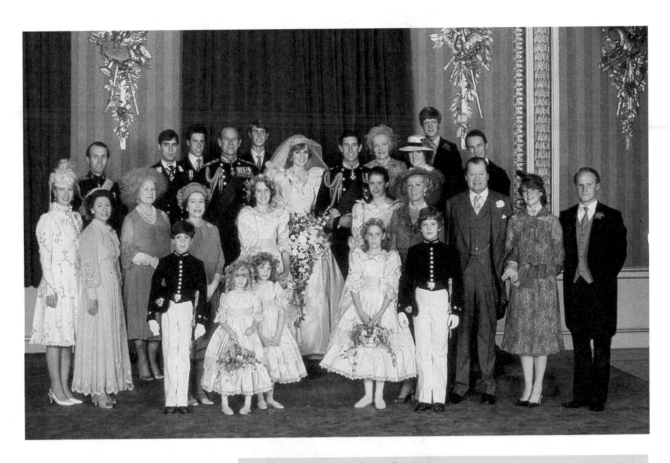

Find the 8 changes see page 103

2005

Every November, Macy's department store brings its **Thanksgiving Day Parade** to New York and to the world via television, as in this 2005 photograph. Multistory-tall balloons representing pop culture characters delight both children and adults as they float among the city's skyscrapers. The festivities officially open the year-end holiday season and the holiday shopping period.

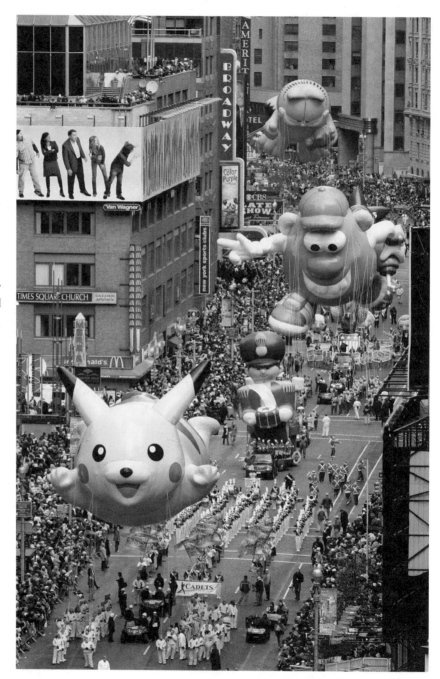

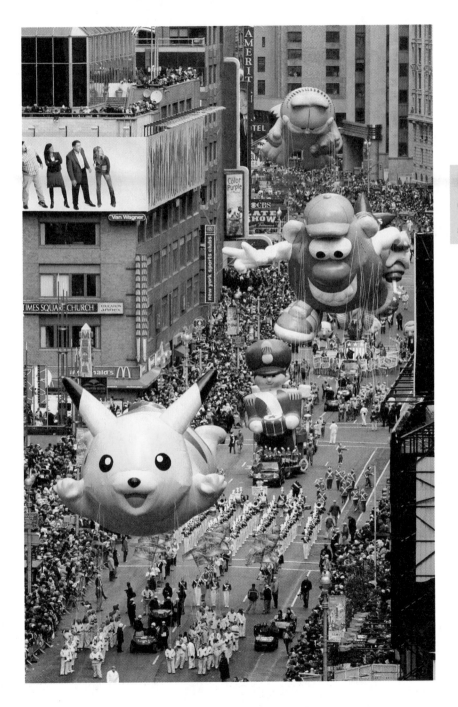

Find the 6 changes

see page 103

see page 103

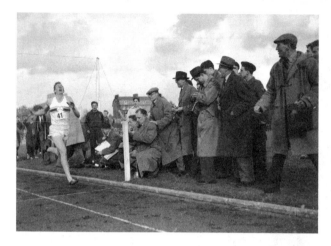
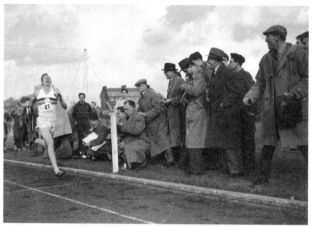
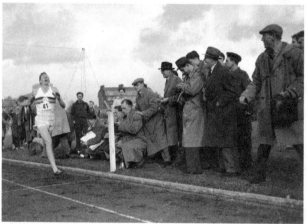
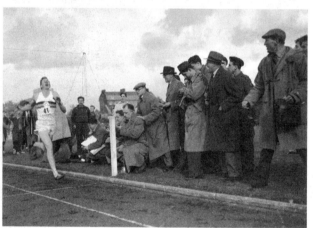

Many believed a man would never run a mile in four minutes or less. Both physical and psychological barriers, it was thought, precluded a human from that athletic achievement. But then came **Roger Bannister**, a 24-year-old medical student, who in 1954 at a track in Oxford, England, astounded the world with a mile run clocked at 3:59.4. The psychological part was probably correct because just a few weeks later another runner beat four minutes, and then several more after that including improved performances by Bannister.

1974

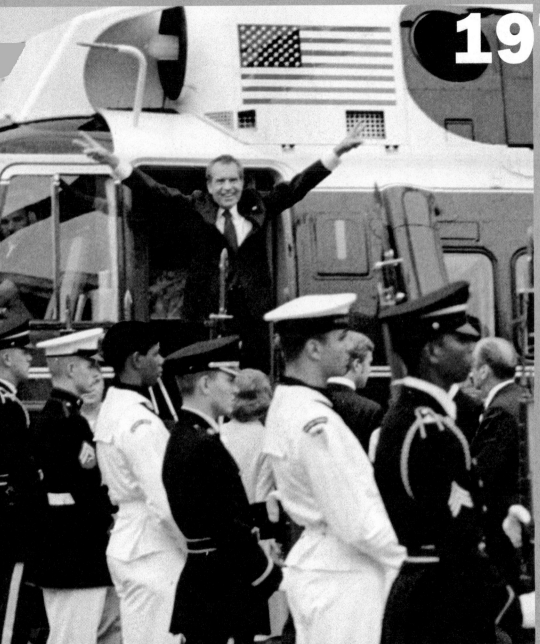

What's wrong?
see page 103

Richard Nixon, recently resigned and departing the White House, gives his signature wave from the door of a helicopter just moments before the chopper lifted off the White House lawn in August, 1974. The Watergate scandal and attempted cover-up took down his administration and left Gerald Ford as president of the United States. There is something missing from this picture, which you should be able to spot.

What's wrong?
see page 103

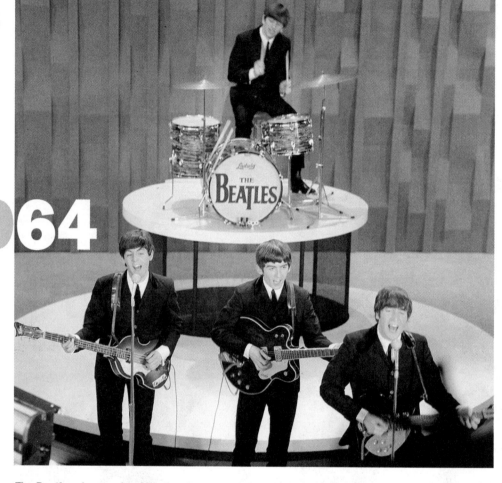

1964

The Beatles, those rockin' kids from Britain with their funny haircuts, took the world by storm with innovative music and crazy antics. The United States was no exception. The Beatles were a big hit on the popular *Ed Sullivan Show* seen here in 1964, and went on to win the hearts of Americans.

What's wrong? see page 103

1936

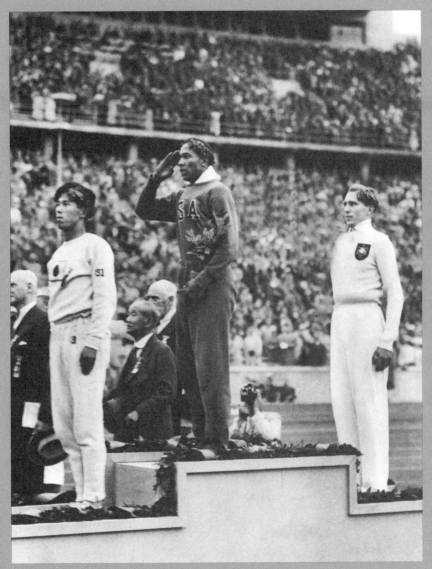

At the 1936 Berlin Olympics American **Jesse Owens** startled the world by winning four Gold Medals in track and field events. It was a historic achievement, and was especially noted by the German hierarchy. Adolf Hitler, architect of the superior race philosophy, was so put off by Owens's startling performance that he left the stadium before the awards. In this picture Owens stands on the winner's podium. Behind him is the German athlete he outperformed. But there is an error in this picture, one especially relevant to the time and place of the Games.

2009

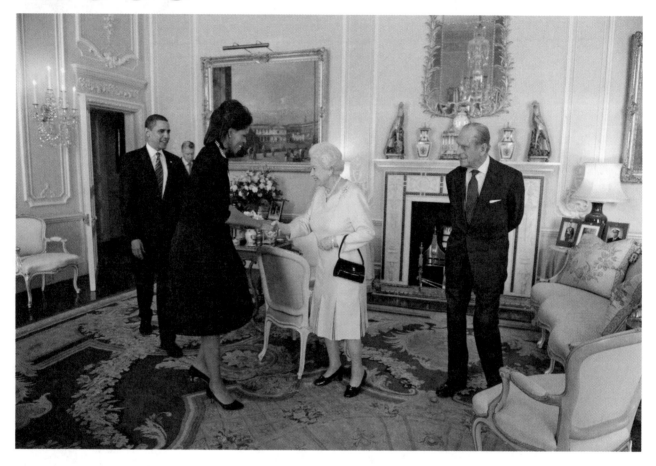

U.S. **President Barack Obama** and his wife **Michelle** met with the Queen of England and Prince Philip in April, 2009, when Obama was in Europe for the G20 meeting. The two couples met in an ornate room at Buckingham Palace in London, for an encounter that was gracious and scored well with the British people.

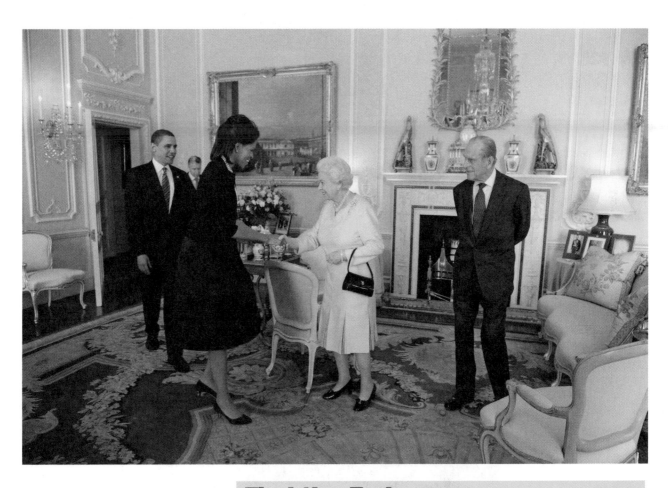

Find the 7 changes see page 104

1969

What's wrong?
see page 104

A man walks on **the moon**. It was a fantasy come true when U.S. astronauts **Neil Armstrong** and **Edwin "Buzz" Aldrin** landed their lunar module on the distant planet and walked across its ashen, desolate surface in 1969. This photo of Aldrin became an icon of the space adventure.

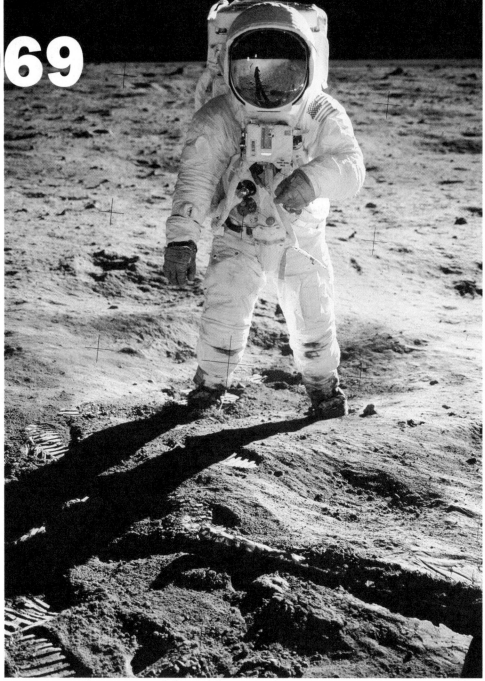

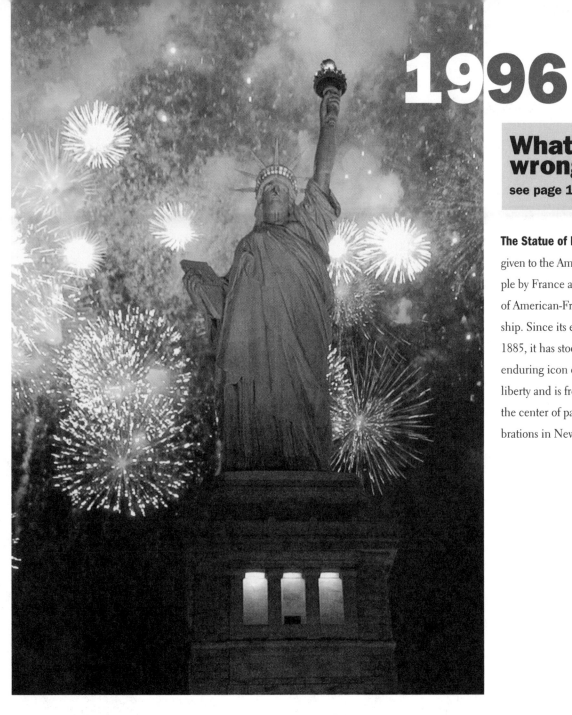

1996

What's wrong?
see page 104

The Statue of Liberty was given to the American people by France as a symbol of American-French friendship. Since its erection in 1885, it has stood as an enduring icon of American liberty and is frequently at the center of patriotic celebrations in New York City.

1934

Bonnie Parker and Clyde Barrow—better known simply as **Bonnie and Clyde**—etched their names in the history of American crime in 1934. The couple cut a swath of murder and robbery across the Midwest and seemed, for many months, too clever for police to track down. But cops caught up with them in Ruston, Missouri. They perished in a violent burst of police gunfire, criminals and lovers to the end.

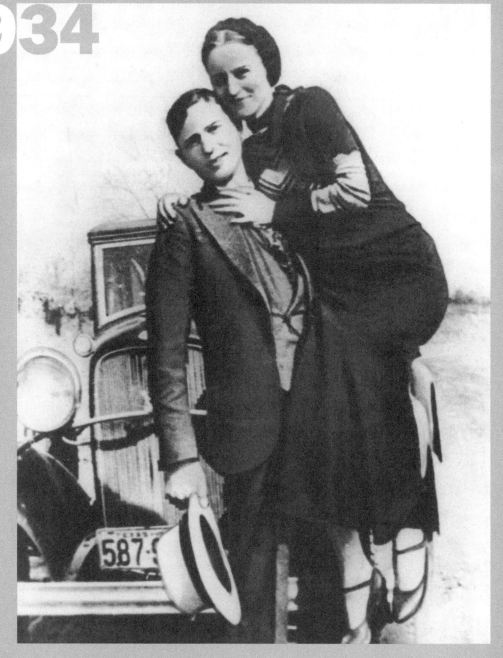

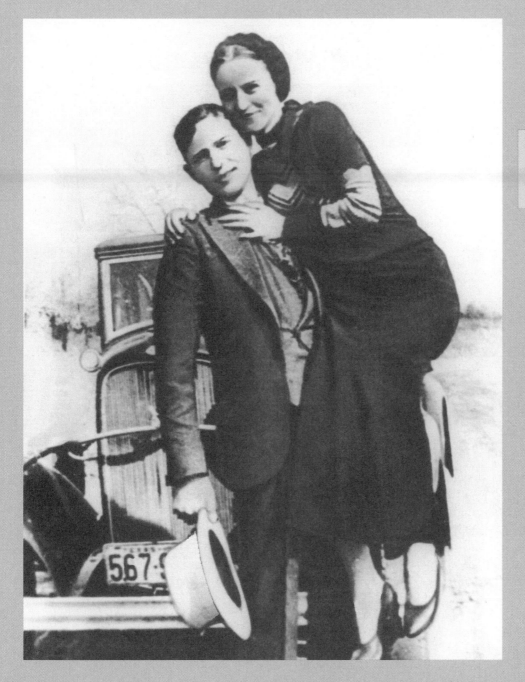

Find the 4 changes
see page 104

21

1955

What's wrong? see page 104

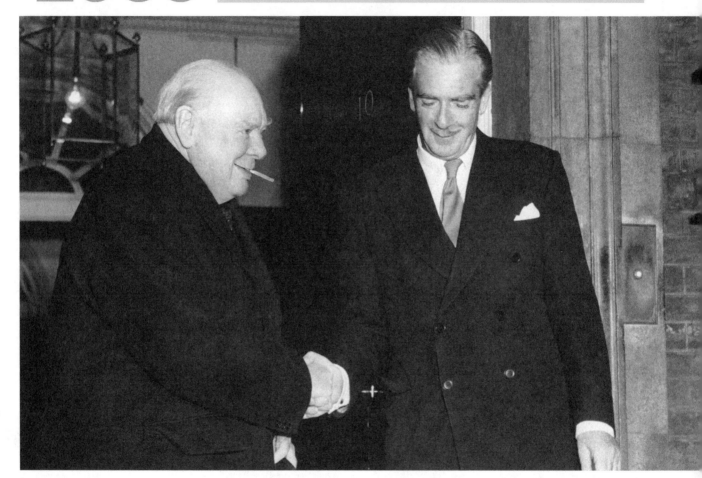

Winston Churchill shakes hands with Anthony Eden after lunch at 10 Downing Street in London in 1955. Churchill, England's World War II leader, was still active on the political scene.

Which is different? see page 105

1970

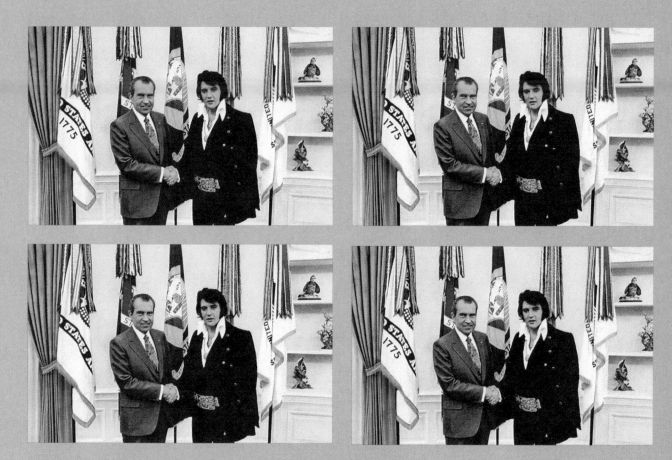

The oddest of odd couples met in the Oval Office of the White House in 1970 when President **Richard Nixon** and **Elvis Presley** chatted briefly and shook hands. Elvis asked for the meeting, presented the president with an elegant pistol, and sought permission to officially aid in fighting drug use by young people. The picture became the most requested photo in the national archives.

1908

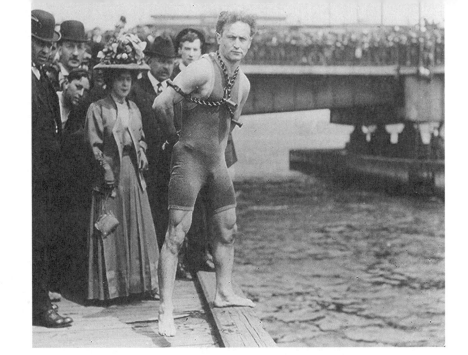

Harry Houdini wowed audiences world-wide with his magic and especially with his death-defying escapes from seemingly impossible lockups. In this 1908 old lantern slide photo, Houdini, chained, handcuffed, and locked, prepares to jump off the Harvard Bridge in Boston. Which he did . . . and surfaced moments later free of his bonds.

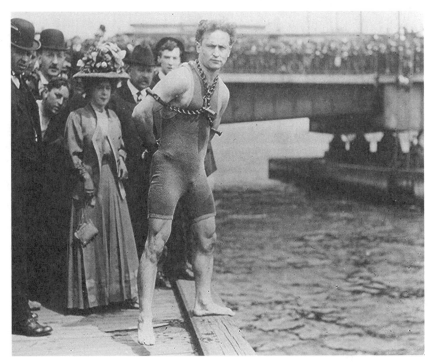

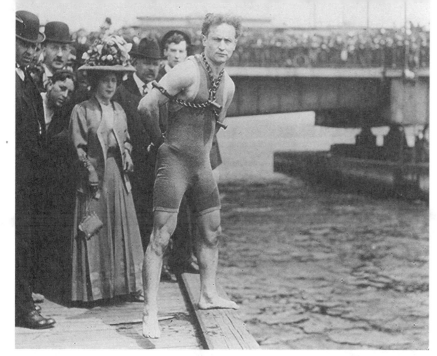

Which is different?

see page 105

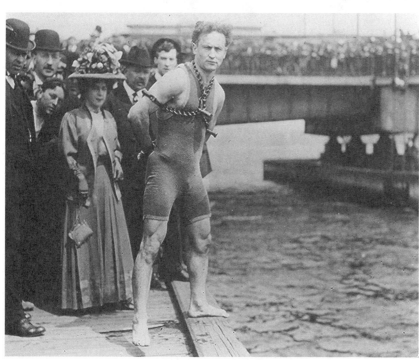

2008

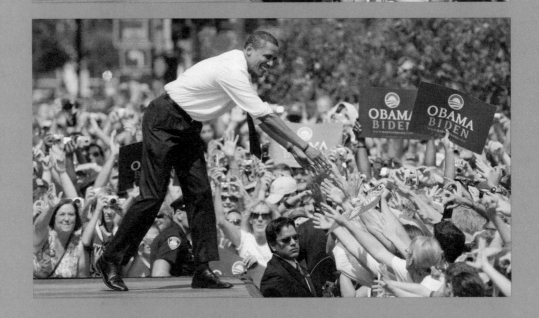

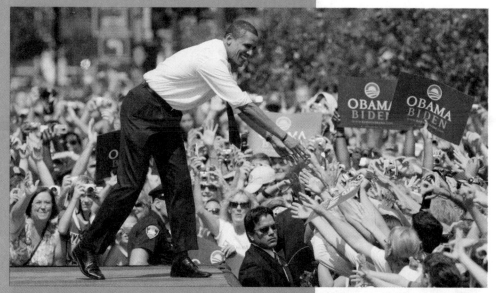

Barack Obama campaigned vigorously and successfully in the autumn of 2008 in pursuit of the U.S. presidency. He spoke to Americans on television and pressed the flesh at countless rallies across the nation. Here he reaches out to supporters in an appearance in Springfield, Missouri.

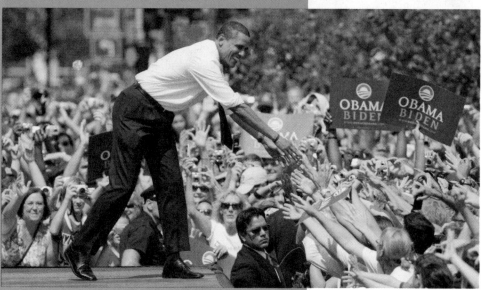

1948

What's wrong? see page 105

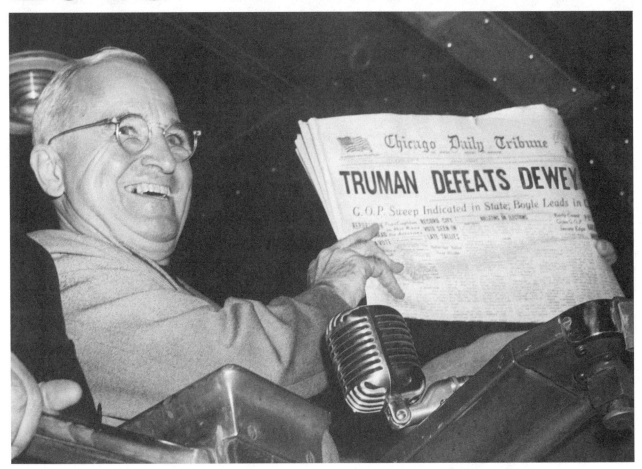

Harry Truman gets the last laugh as he holds up a copy of a newspaper with the 1948 presidential election results bannered across the front page. But why make such a big deal over a newspaper headline?

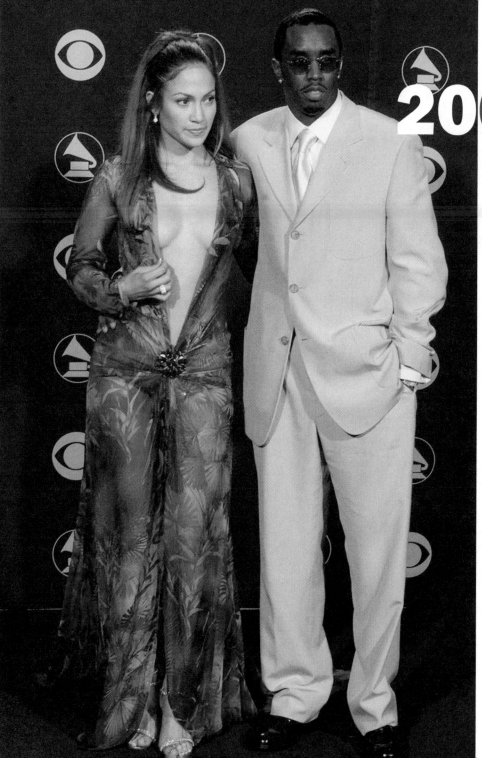

2000

What's wrong?
see page 105

Jennifer Lopez, accompanied by pal **Sean (Puffy) Combs**, was the talk of the town when she appeared in this gown at the 2000 Grammy Awards in Los Angeles. The dress caused all sorts of chatter on the celebrity circuit but this picture is missing a small detail.

2007

Which is different? see page 105

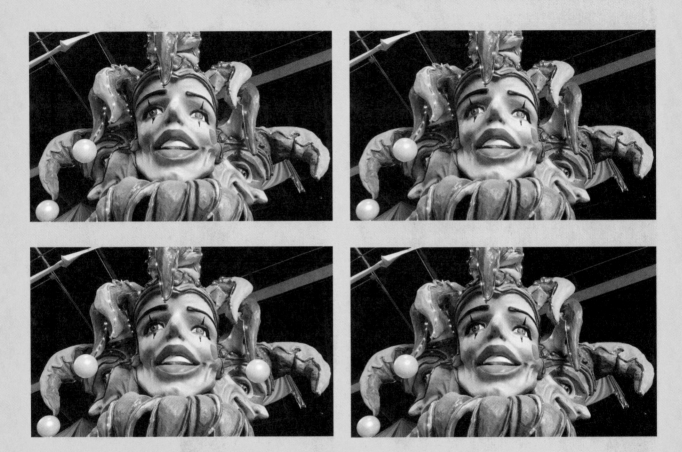

One of the decorations for a **Mardi Gras** parade in 2007 awaits the start of festivities in the studio where it was created.

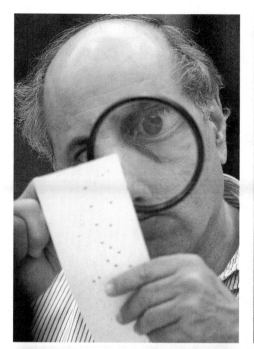

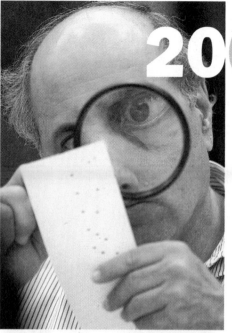

Which is different?
see page 105

The chad, the electronic voting cards that are or are not punched properly, figured prominently in the presidential election of 2000. Poorly punched chads were challenged, re-examined, viewed, discussed, and ended up in court until finally the election was settled. Democrats believed they were robbed. These four photos show a chad being viewed by a judge through a magnifying glass in Florida.

1918

On November 11, 1918, World War I, the "war to end all wars," came to an end. Spontaneous celebrations broke out in the trenches of Europe, in the streets of London, in the heart of New York and elsewhere in the world. Young and old, soldiers and civilians, cheered the conclusion of a brutal conflict that killed millions. November 11th came to be known as **Armistice Day**. The spirit of the day was exuberant as with this jubilant group aboard an overloaded truck in New York's Times Square.

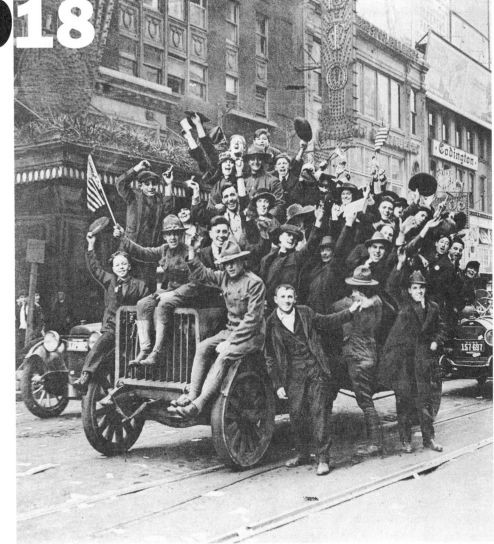

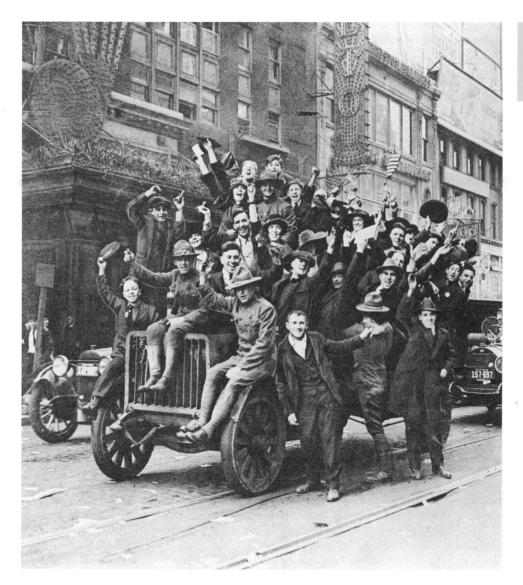

Find the 6 changes
see page 105

1948

What's wrong?
see page 105

Babe Ruth, the home-run king, the sultan of swat, one of baseball's all time heroes and a genuine American icon, makes his final appearance in Yankee Stadium in June 1948, years after his playing days. For the final time the ailing Ruth hears the roar of the crowd; he died a few months later. This poignant picture was made at that event, but there is a serious error in the photo. Spot it if you can. This puzzle is an easy one for baseball buffs; tougher for others.

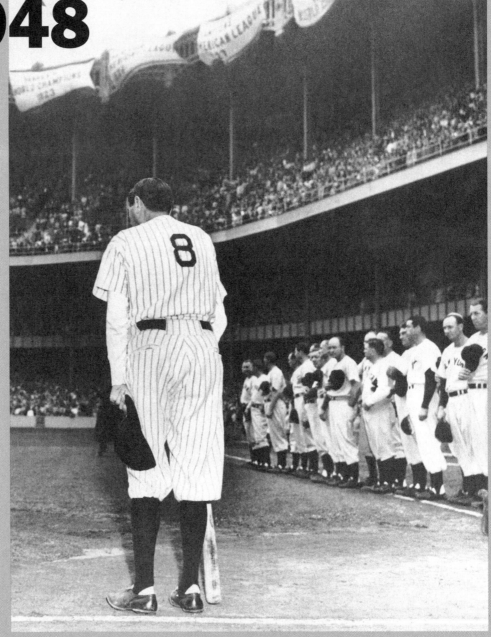

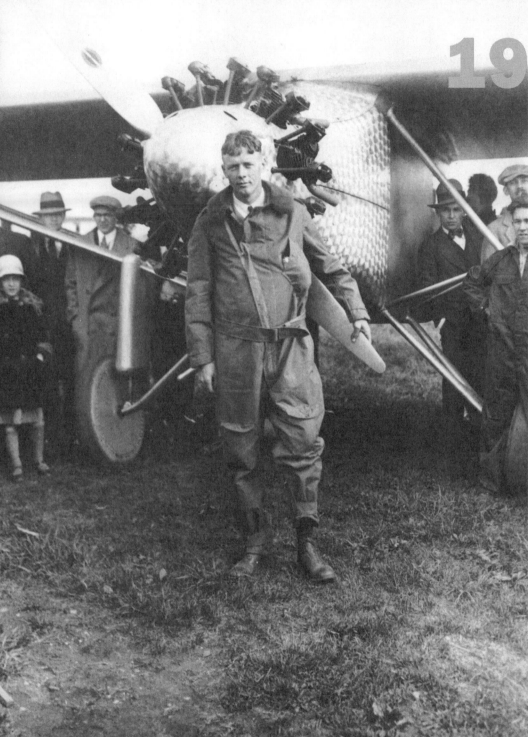

1927

What's wrong?
see page 106

Charles Lindbergh stands in front of the plane he flew solo from New York to Paris in 1927, a historic achievement that opened new opportunities for air travel. Ready in his flight suit with his plane at the runway, Lindbergh looked boyish as he posed for this famous picture prior to departure.

1862

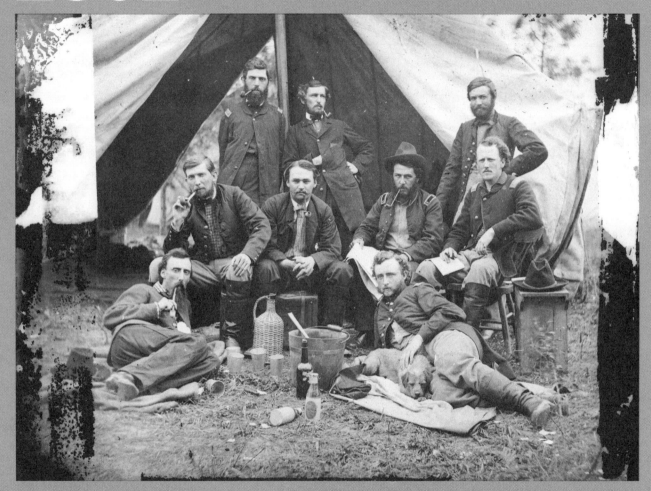

The American Civil War nearly brought an end to the union of states. The war pitted brother against brother, neighbor against neighbor. The battles were furious; the death toll devastating. Though photography was newly born, cameramen visited

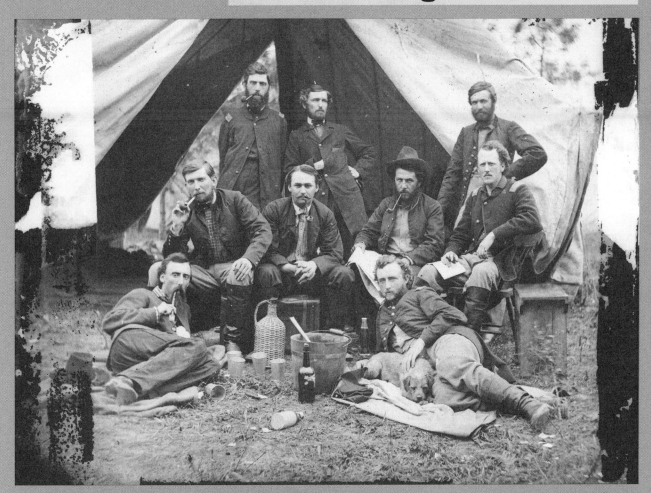

battlefields and campsites to record the armies. In this photo a group of Union officers pose outside their tent at a Virginia campsite. Lieutenant George Custer, who would be killed during the Indian wars later, reclines at right.

1996

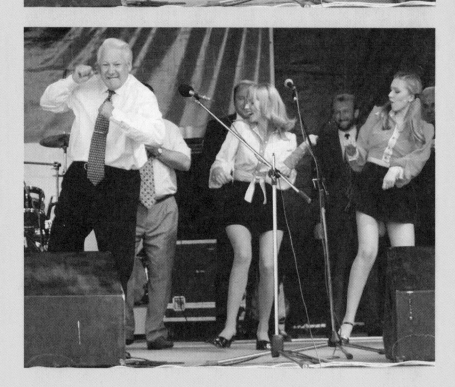

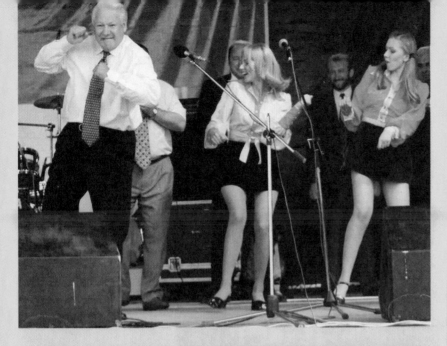

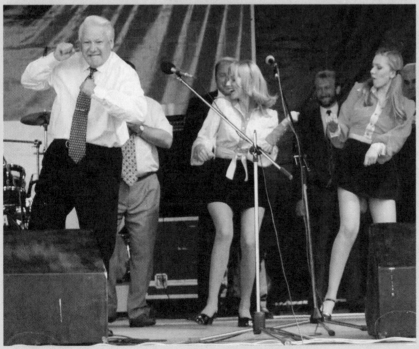

Which is different?
see page 106

Boris Yeltsin, president of the new Russia, campaigned for re-election in 1996 like any other politician. Here, looking more like a conventioneer than the traditional Russian bear, he dances at a Rock concert in Rostov.

1989

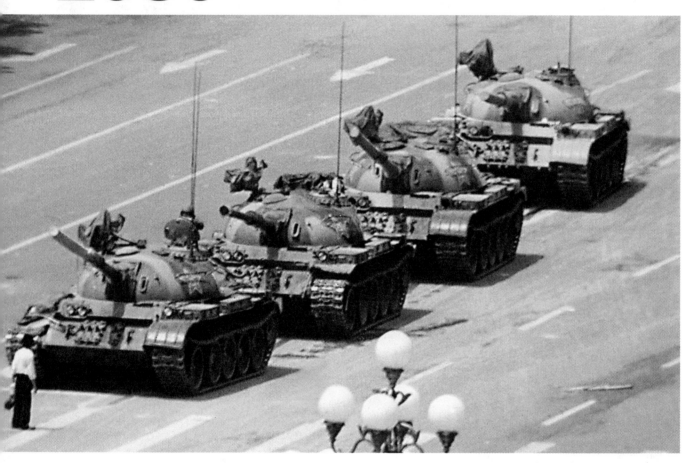

Tiananmen Square in Beijing, China, was the scene of a bloody attack by the Chinese military on student protesters in 1989. The next day tanks patrolled a nearby street. As the tanks rolled along, they were confronted by a lone man. He pleaded

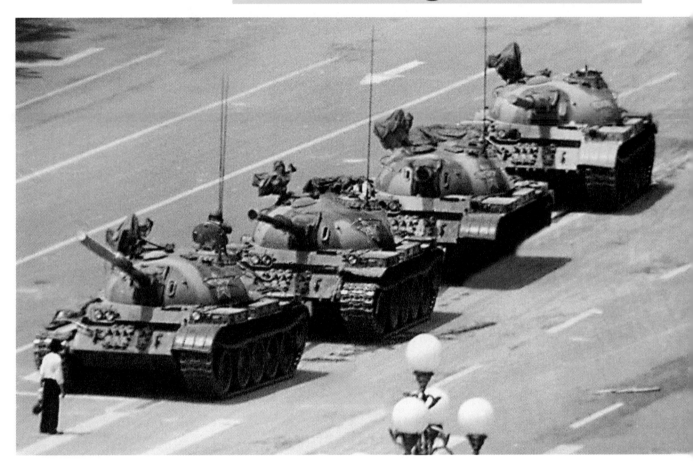

with the soldiers to stop the killing. After several tense moments, bystanders hustled the man away and the tanks proceeded. The picture remains a testimony to the Tiananmen massacre.

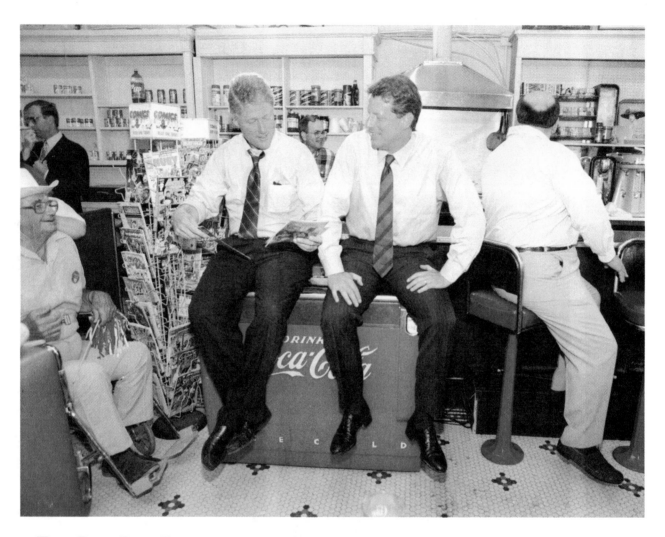

1992

Governor **Bill Clinton** and Senator **Al Gore** share a soft drink as they relax after a campaign rally in Corsicana, Texas, in the 1992 U.S. presidential campaign. Campaigners, weary and thirsty, often stop in diners and convenience stores as they pause in their frontline vote seeking. The convenience store backdrop makes the politician seem a "regular guy." The Democratic running mates came out on top, defeating the senior George Bush, who was running for a second term.

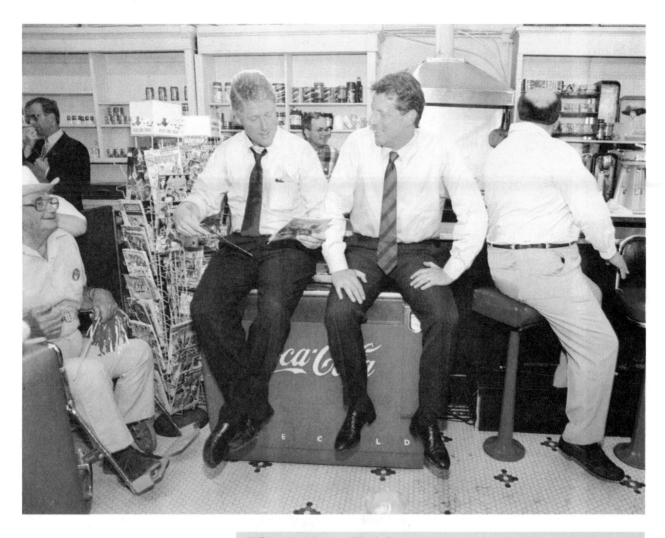

Find the 7 changes see page 106

1945

This photo of American infantrymen and Russian soldiers shaking hands at the **Elbe River** in 1945 was one of the final signals that World War II in Europe was at last coming to an end. Eastbound Americans and westbound Russians linked up in April as they fought their way across Germany. The European war ended in May, the Pacific war concluded in August, and finally, the world's greatest conflict was over.

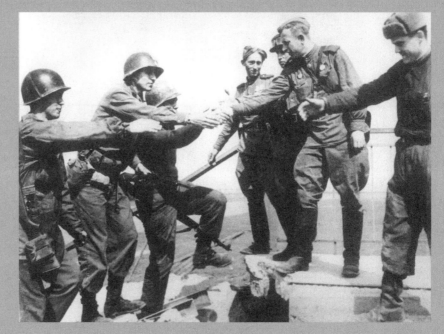

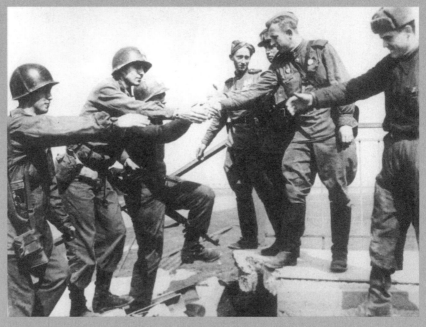

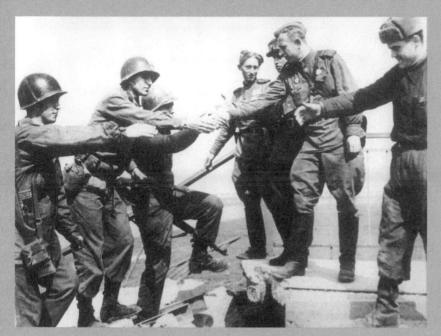

Which is different?
see page 107

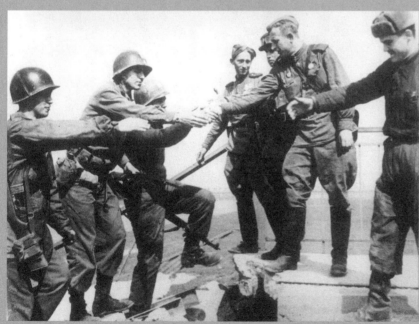

What's wrong?
see page 107

1960

John Kennedy narrowly won the 1960 presidential race against Richard Nixon and became the first Roman Catholic to hold the nation's highest office. This picture shows him arriving in Los Angeles to attend the Democratic National Convention, where he was nominated as the party's candidate. But a serious error has been entered into this picture.

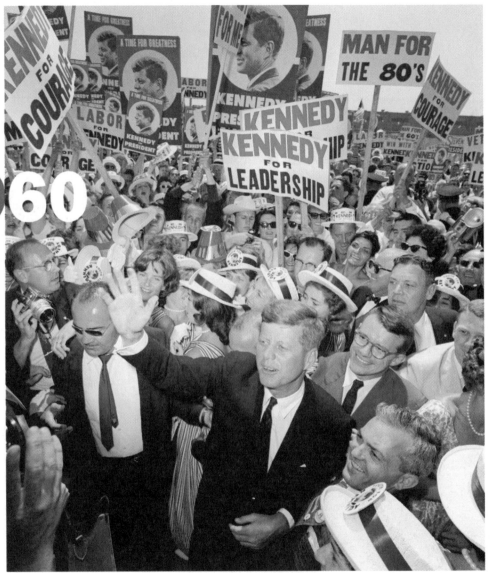

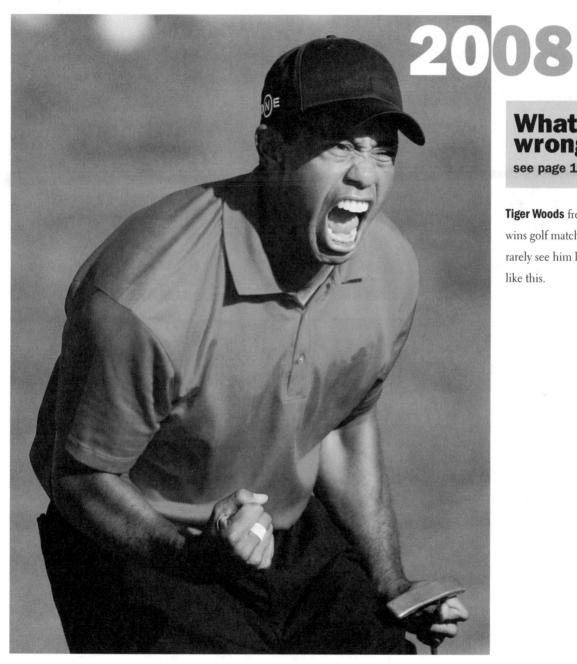

2008

What's wrong?
see page 107

Tiger Woods frequently wins golf matches but you rarely see him looking like this.

1988

Which is different? see page 107

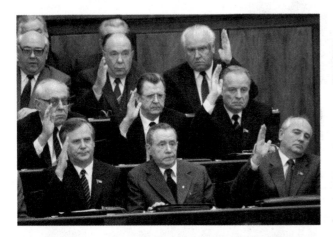 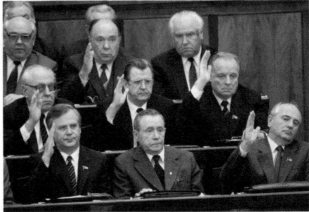

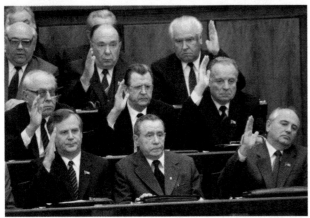 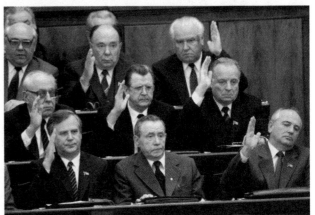

Winds of change blew through the Soviet Union in 1988 and nothing predicted the future as much as this classic photo of glum, longtime Communist leader **Andrei Gromyko**. All hands are raised by Soviet Politburo members to vote him out as president, thereby turning the presidency over to Communist Party chief Mikhail Gorbachev, at right. The rest is history.

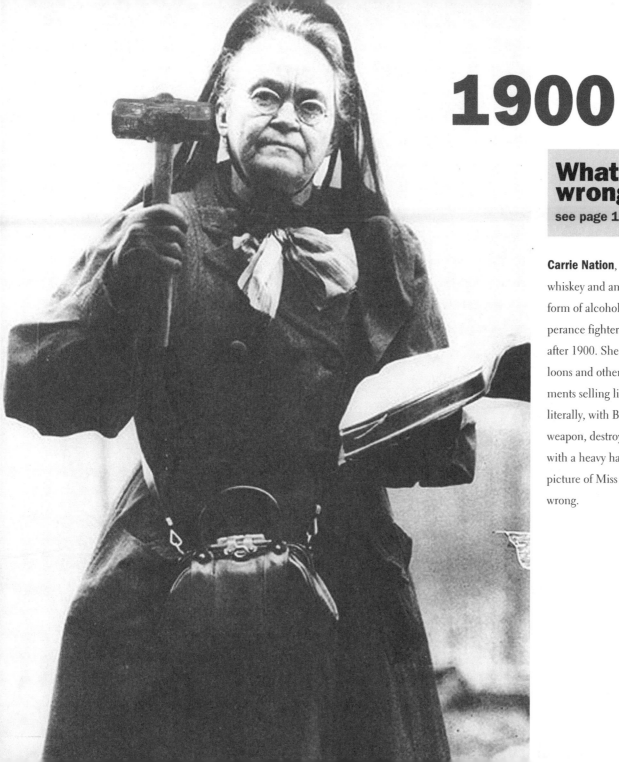

1900

What's wrong?
see page 107

Carrie Nation, who hated whiskey and any other form of alcohol, led temperance fighters before and after 1900. She entered saloons and other establishments selling liquor and literally, with Bible and weapon, destroyed them with a heavy hand. But this picture of Miss Carrie is wrong.

1869

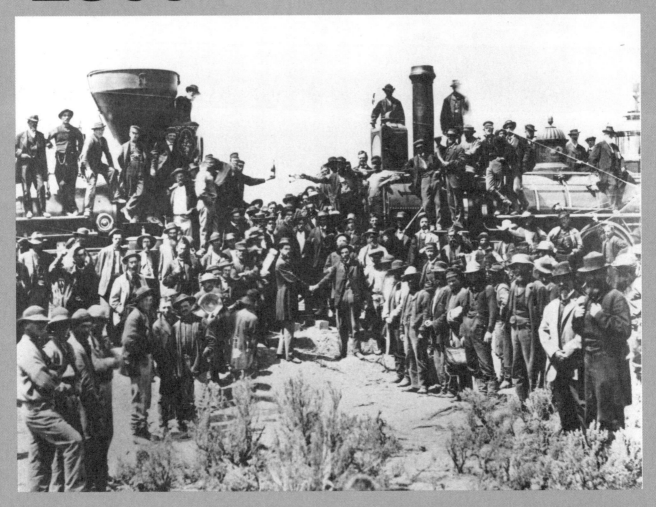

The American move westward reached its zenith in 1869 when the nation was joined coast to coast by railroads. In the spring of that year the Union Pacific's locomotive 119, right, and the Central Pacific's Jupiter edged forward to meet at

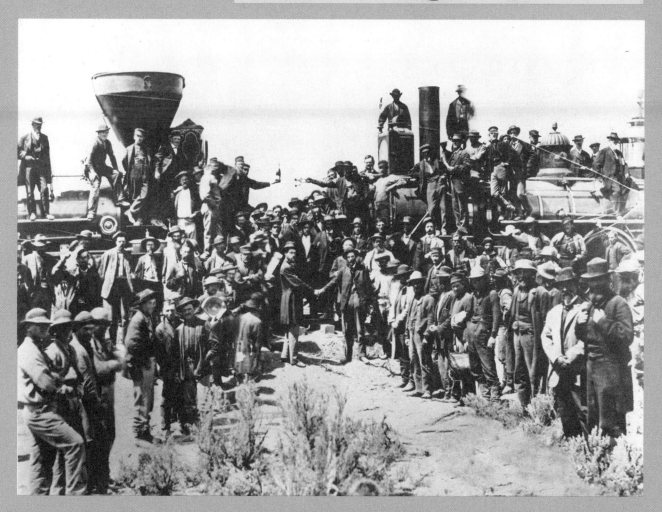

Promontory, Utah. A final **golden spike** linked the rails. This picture captured
the historic moment as work crews, railroad officials, and engineers celebrated
the union.

1945

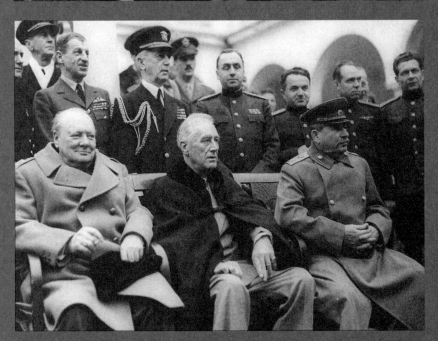

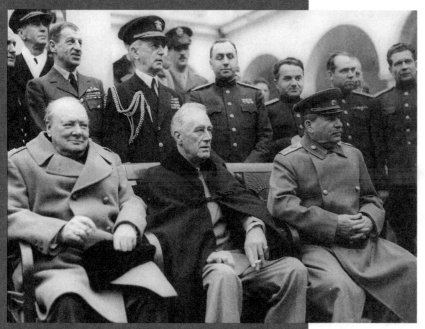

Which is different?
see page 107

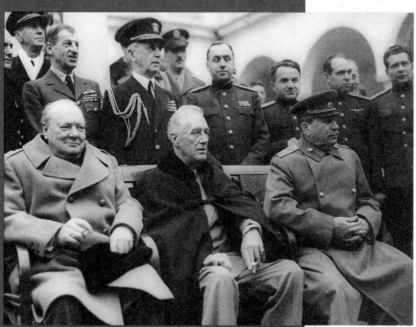

The Big Three—the leadership of the Allied forces during World War II—met at **Yalta** in February 1945. With the end of the war in sight Winston Churchill, Franklin Roosevelt and Josef Stalin discussed the future of a post-WWII era in talks that could, and to some extent did, chart the future of much of the world.

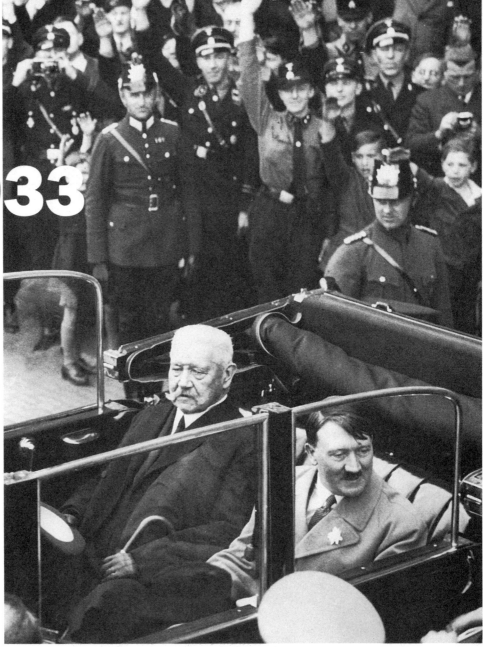

1933

German president **Paul von Hindenburg** and Chancellor **Adolf Hitler** ride through a crowd during a Berlin May Day rally in 1933. Hindenburg died a year later and Hitler immediately seized power, taking history down a new and dangerous road that led to World War II.

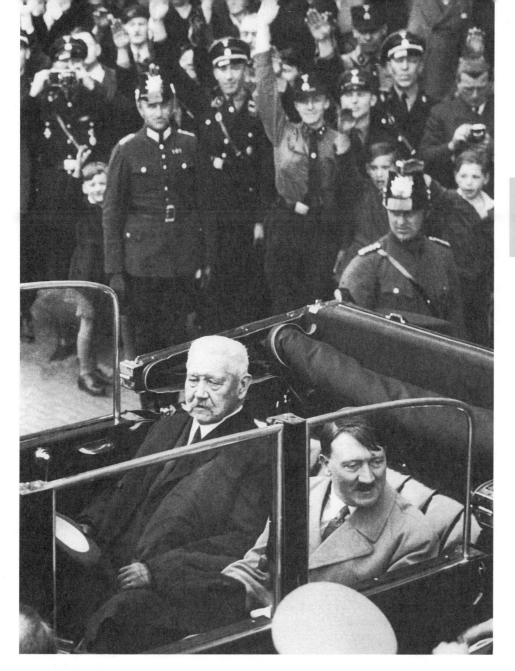

Find the 6 changes
see page 108

55

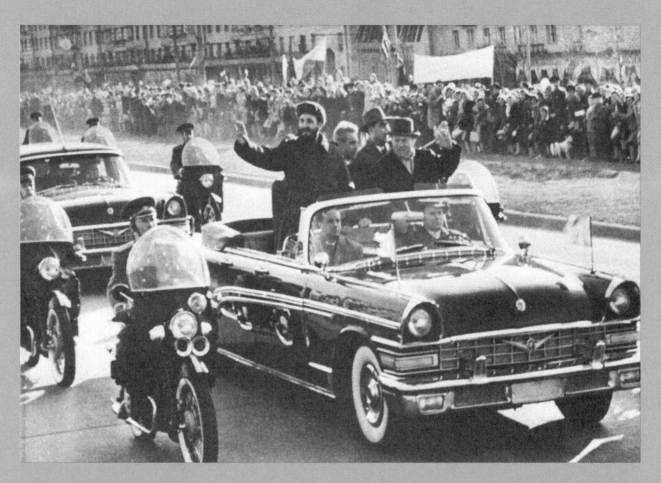

1963

Fidel Castro, after a long revolutionary battle, became the Premier of Cuba and soon developed a special relationship with Soviet Premier **Nikita Khrushchev**. Their friendly connection was amply displayed when Castro visited the Soviet Union in 1963 and received the cheers of Muscovites along a Moscow parade route.

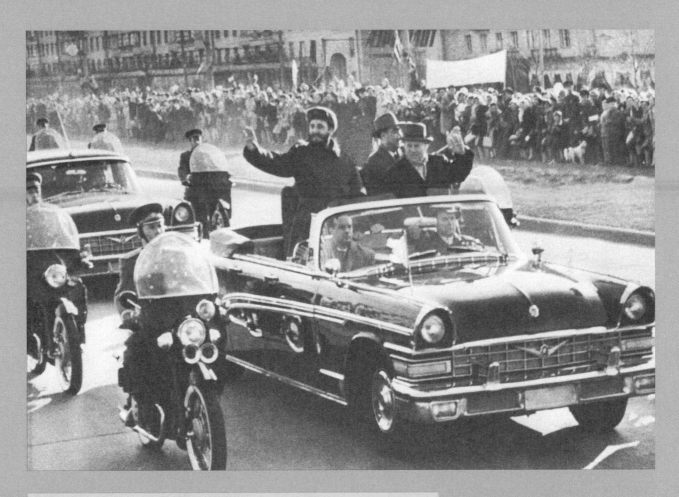

Find the 5 changes see page 108

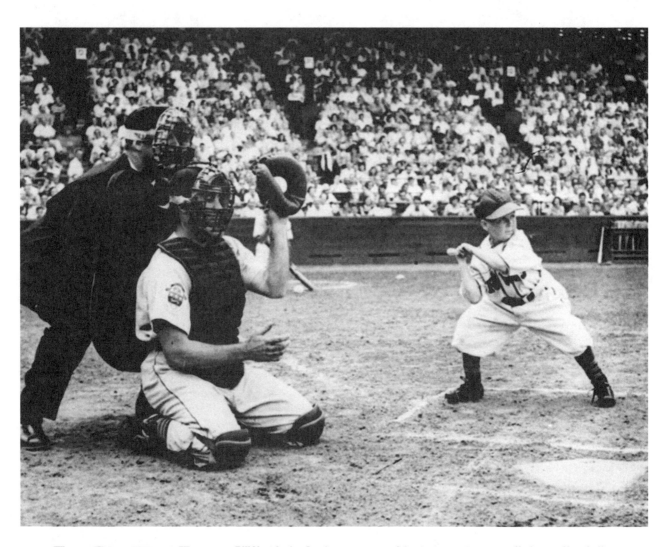

1951

Bill Veeck, the flamboyant owner of the St. Louis Browns, pulled one of baseball's greatest exploits in 1951 when he called on Eddie Gaedel, a 3-foot-7-inch stuntman, to pinch-hit in a game against the Detroit Tigers. Veeck's exploit was sheer publicity though Gaedel's appearance was legitimate. He walked on four straight pitches, but another player who

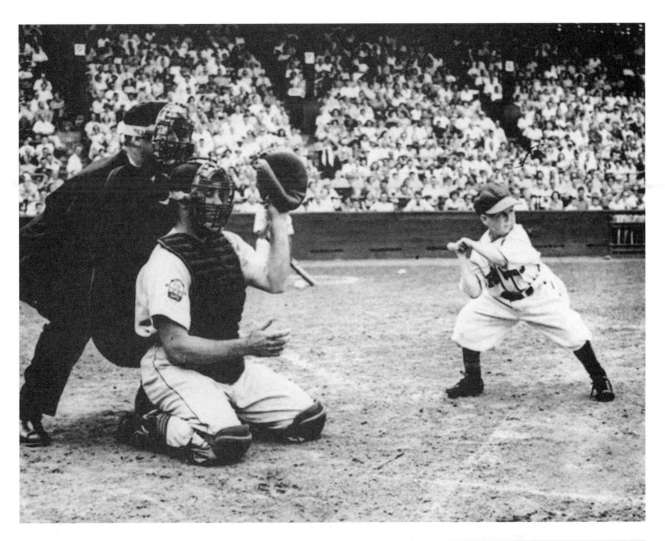

pinch ran for Gaedel was left on third and the Tigers won 6–2. Gaedel's brief moment as a major-league player remains in baseball record books despite the bizarre nature of his appearance. Eddie Gaedel did other stunts for Veeck by appearing as a space alien at ball games and as a refreshment vendor that "would not block the fans' view of the game."

Find the 5 changes
see page 108

1989

Germans from East and West dance and sing atop the **Berlin Wall** in 1989. The collapse of the wall twenty-eight years after it was built signaled an end to the Cold War. The barrier, which contributed to the continuance of an East and West Germany, was built to halt the flow of East Germans to the West in the years before and up to 1960.

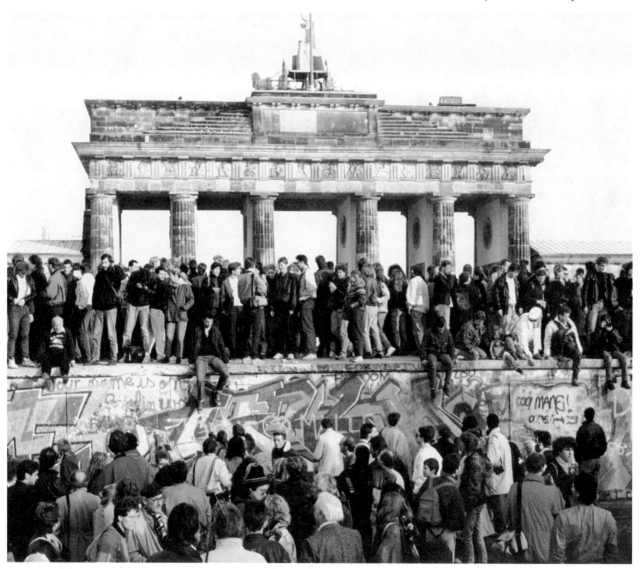

Thousands flocked to the wall, particularly near the Brandenburg Gate, as it was pulled down section after section by residents of both East and West Germany. The two Germanies were later united into a single nation.

Find the 5 changes

see page 108

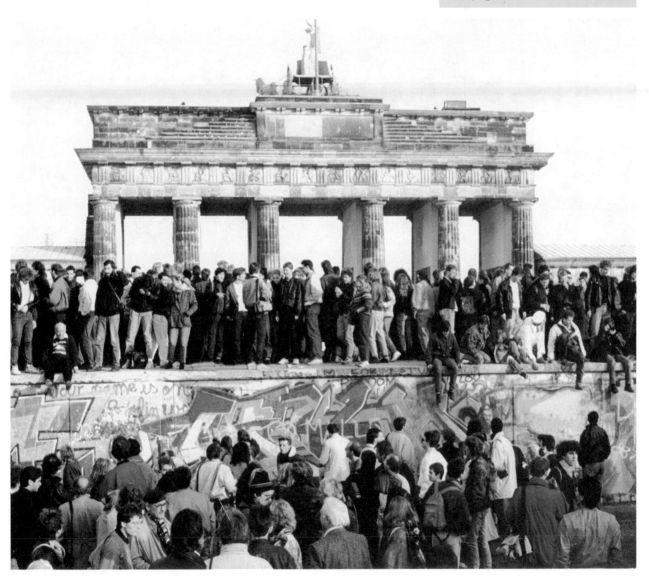

1933

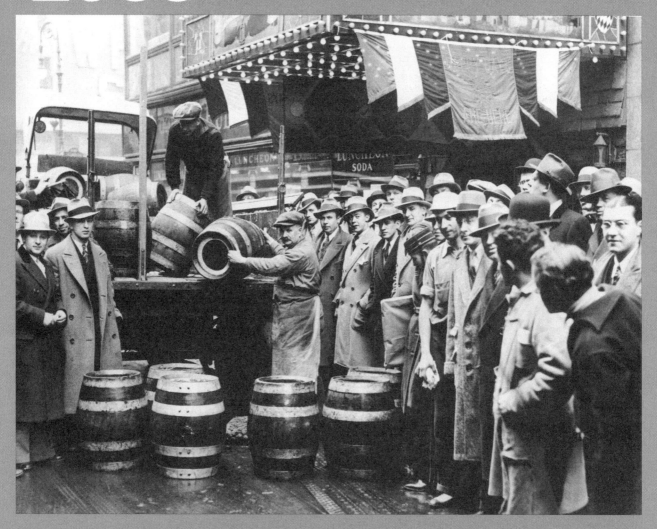

In the early 1930s, newspapers often printed pictures of ax-wielding police officers splitting open confiscated kegs of beer and pouring the content into sewers. The scene, however,

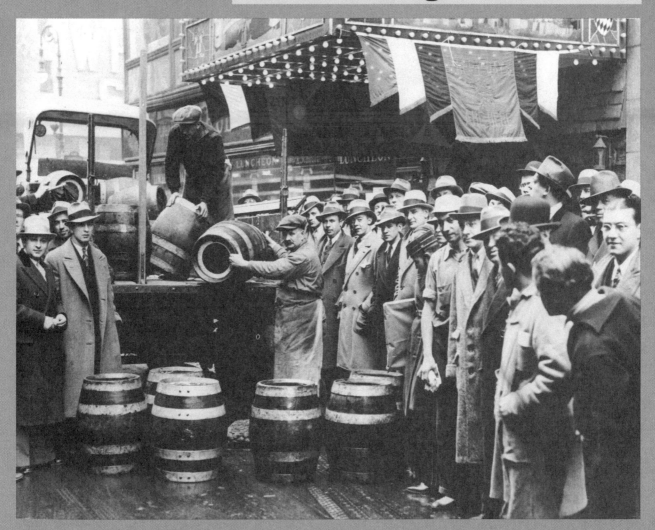

changed in 1933. **Prohibition ended**, and beer kegs like these were once again delivered to restaurants on New York's Broadway—and not a cop in sight to halt the process.

2004

What's wrong?
see page 109

The Rockettes, dancing wonders of Radio City Music Hall's Christmas Spectacular, go through their routine at a performance in 2004. But something is amiss.

Which is different? see page 109

1955

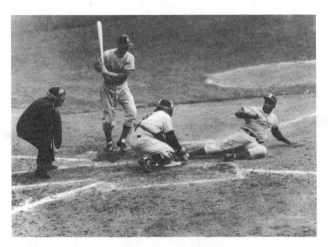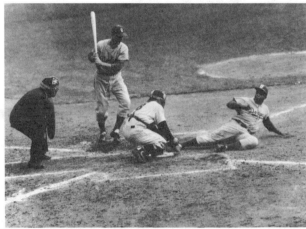

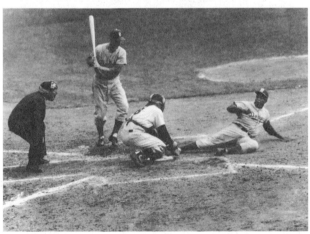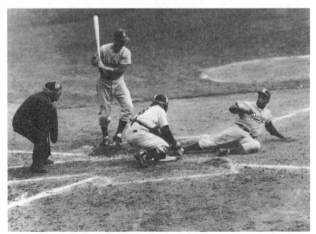

Jackie Robinson, who broke the color line in professional baseball, was a speedy base runner and frequently stole home by beating the pitched ball to the plate. Here he slides in safely against Yogi Berra in the first game of the 1955 Yankee-Dodger World Series. The ump's call set Yogi afire, and he argued loud and long that he tagged Robinson out. The ump said no, Jackie was safe. Four reproductions of the photo are offered here, all the same . . . well, not quite.

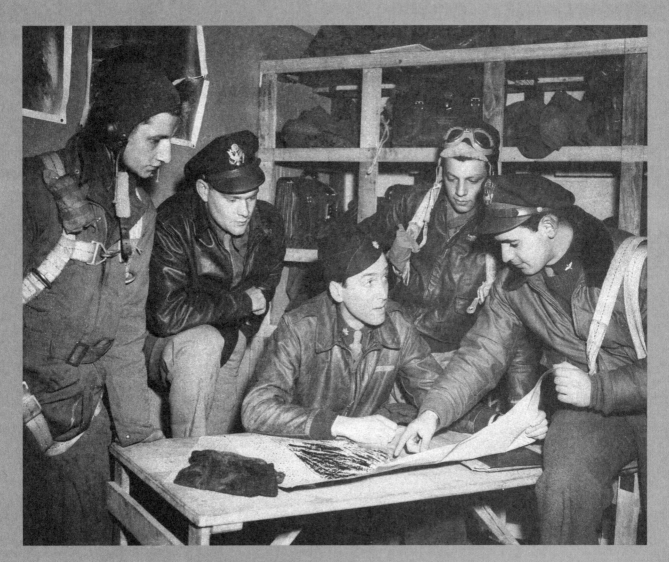

1944

Actor **Jimmy Stewart**, center, wasn't acting when he posed for this picture in 1944. He and his crew were preparing for a bombing run over Germany from their base in England. Stewart, a captain and flight commander when this photo was made, rose to the

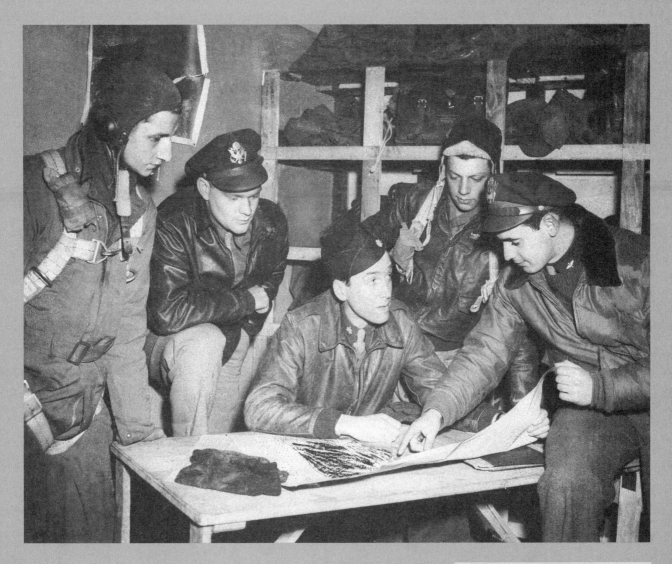

rank of colonel before the war ended. He flew more than twenty missions over Europe. Highly decorated for his military activities, Stewart became one of the nation's most popular and successful Hollywood performers.

Find the 7 changes

see page 109

1898

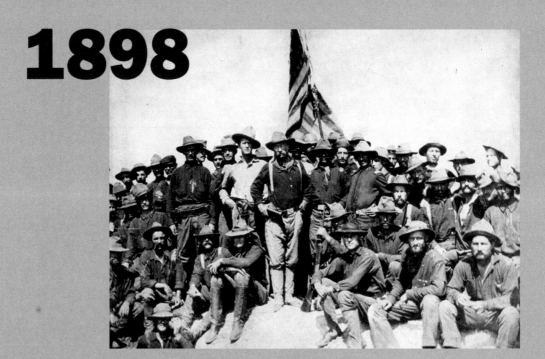

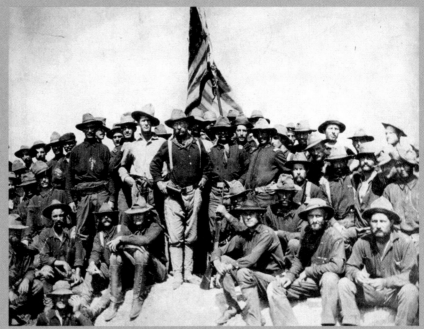

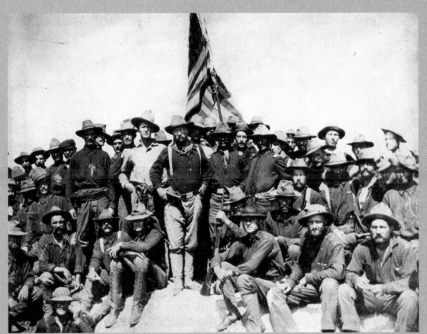

Which is different?
see page 109

Teddy Roosevelt and his **Rough Riders** won the battle of San Juan Hill during the Spanish-American War. Roosevelt, center below the flag, and his soldiers pose atop the hill after the battle for a picture that became an icon of the fiesty military leader who would become president.

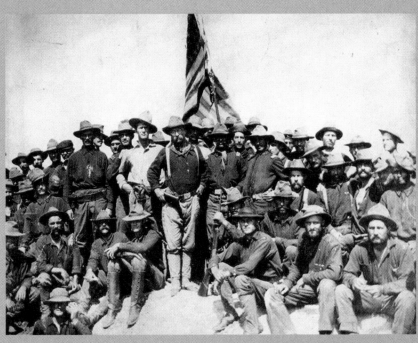

1934

John Dillinger, the notorious bank robber and gangster, shown here in a Chicago morgue, was slain in 1934 outside a movie theater on the city's north side. The morgue was opened to the public, and the curious were allowed a close-up look at the bandit. It was never clear whether the viewing was meant to assure the populace that Dillinger was dead, or whether the cops wanted to show people what happened to bad guys in the era of the gangster.

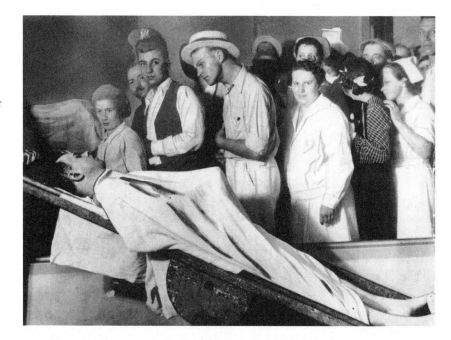

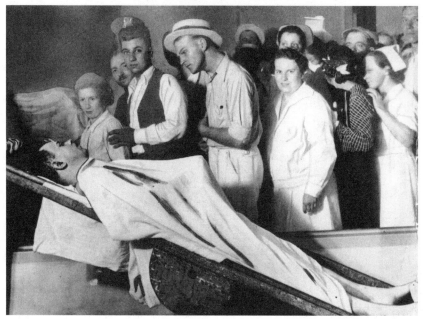

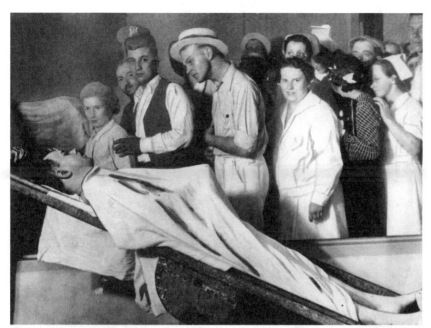

Which is different?
see page 109

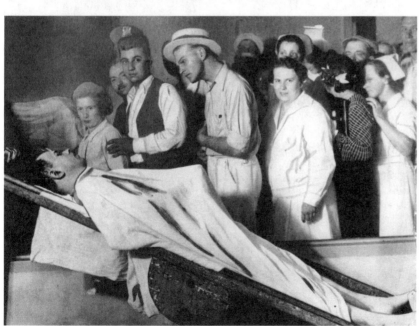

2007

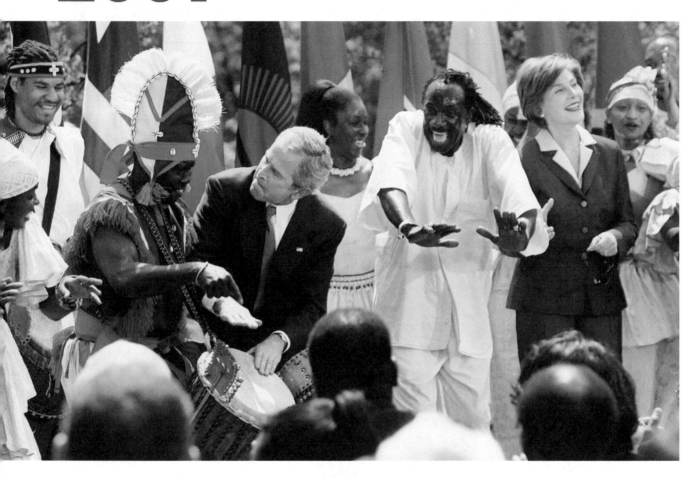

President Bush gets into the swing of it as he plays the drums during a 2007 White House visit by the KanKouran West African Dance Company. The group visited the White House to mark Malaria Awareness Week and set up a vigorous musical session, which included First Lady Laura Bush.

Find the 5 changes see page 110

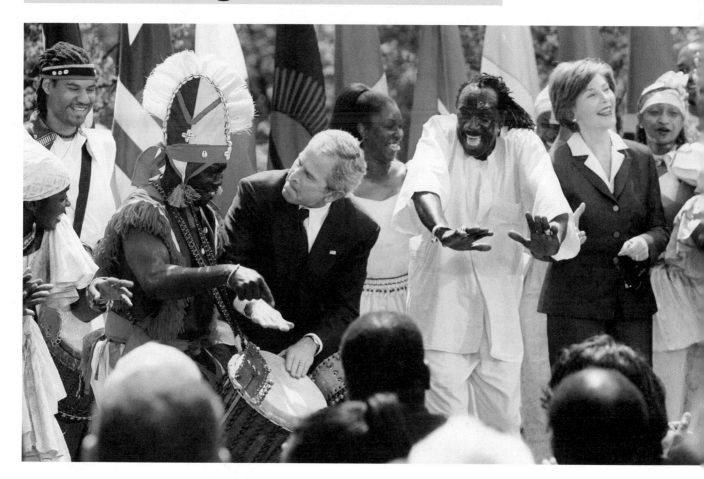

1945

The end of World War II in 1945 was cause for celebration. Happiness reigned in the streets from London's Trafalgar Square to Times Square in New York. This spontaneous scene, an enduring icon of V-J Day and the conclusion of the world's greatest conflict, was actually made by two photographers—one working for a magazine and the other a military photographer. The two pictures were virtually identical and captured a moment forever embedded in the hearts of Americans. This version is from the military photographer.

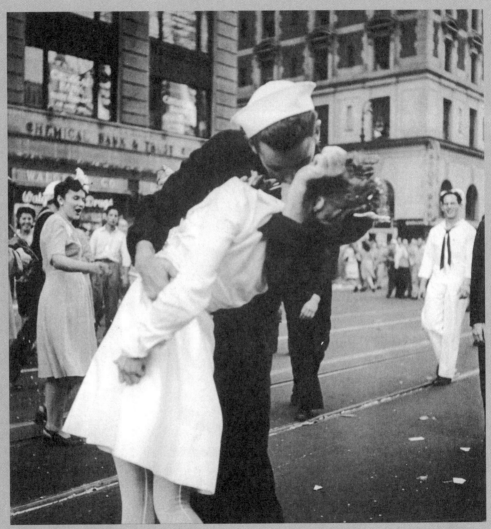

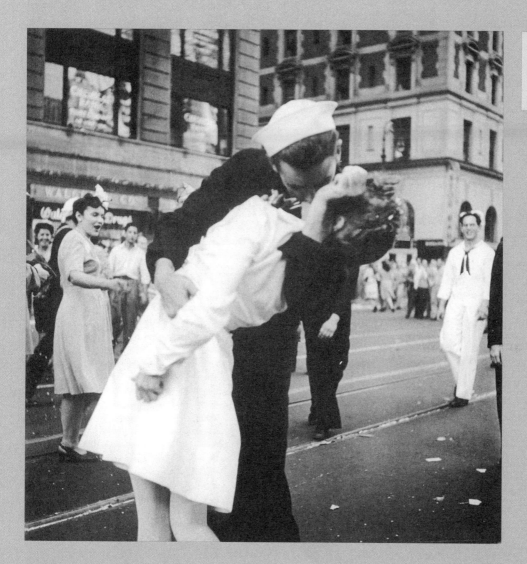

Find the 5 changes
see page 110

75

2000

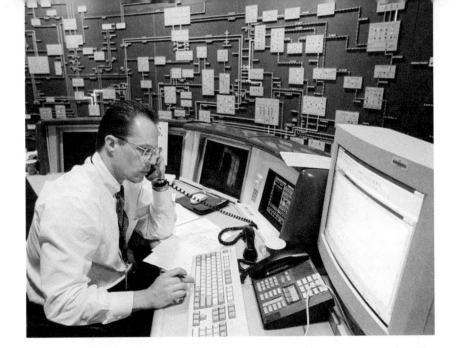

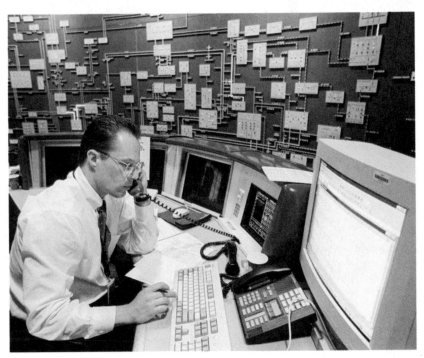

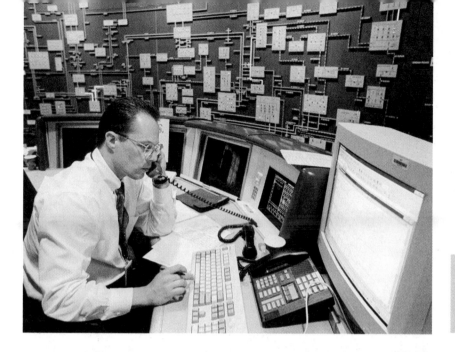

Which is different?
see page 110

The turn of the millennium—New Year's Eve 2000—offered the possibility of a communications breakdown worldwide. Computers everywhere, it was feared, were not properly coded to handle date procedures as the calendar moved from 1999 to 2000. The issue was referred to as the Y2K problem. As it turned out, the scare was unfounded. The world marked the millennium with parties and fireworks. Computers hummed along unaffected. Those responsible for computer maintenance worked hard and long to protect against possible disaster, as does this systems operator in Newark, New Jersey.

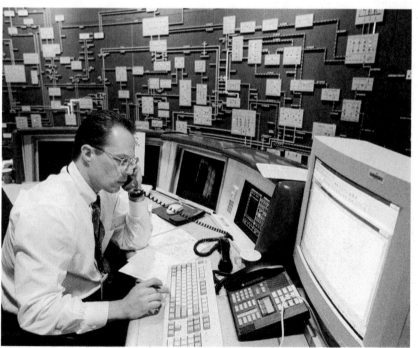

1953

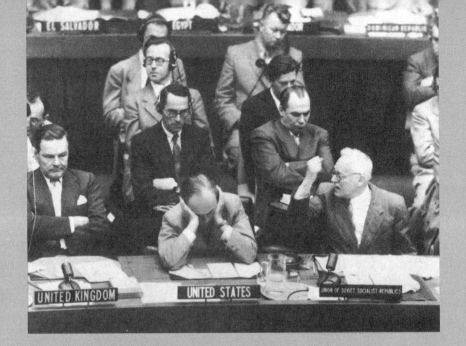

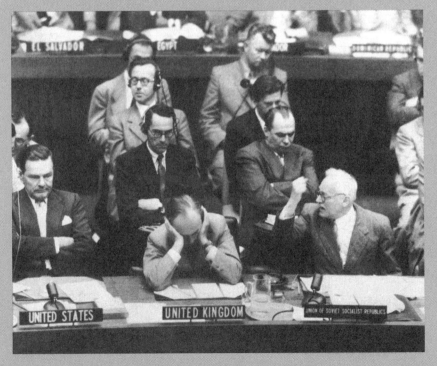

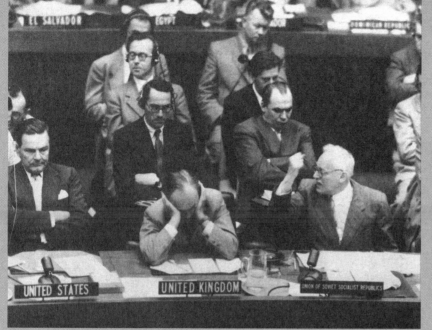

Which is different?
see page 110

Andrei Vishinsky, a Soviet delegate to the United Nations, gestures emphatically as he accuses the United States and its allies of trying to ram through their conditions for a Korean War peace conference in 1953. It was one of many Vishinsky rants which only led to British ambassador Sir Gladwyn Jebb covering his ears and U.S. ambassador Henry Cabot Lodge looking grim.

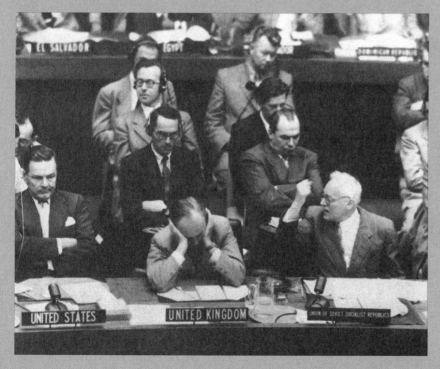

2008

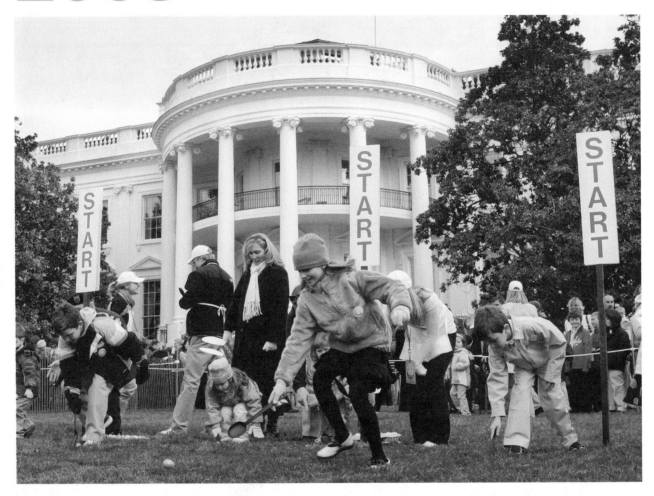

Each year the president of the United States invites children to an **Easter egg roll** on the lawn of the White House in Washington, DC. Kids have a ball, as costumed rabbits and other Easter icons stroll through the crowd offering advice and humor. The Easter egg roll in this picture took place in 2008.

Find the 6 changes see page 110

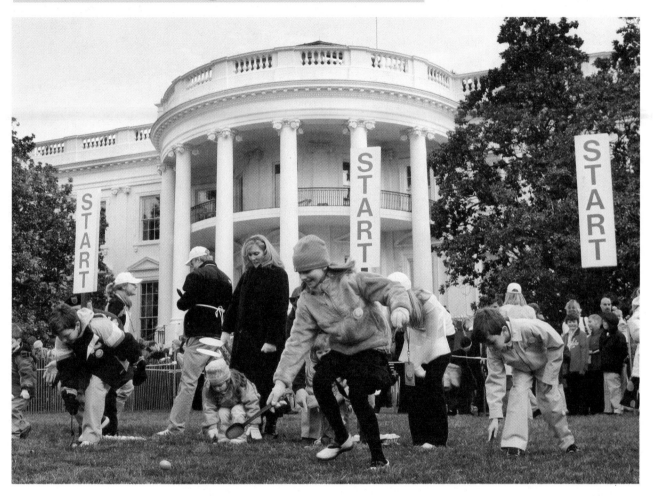

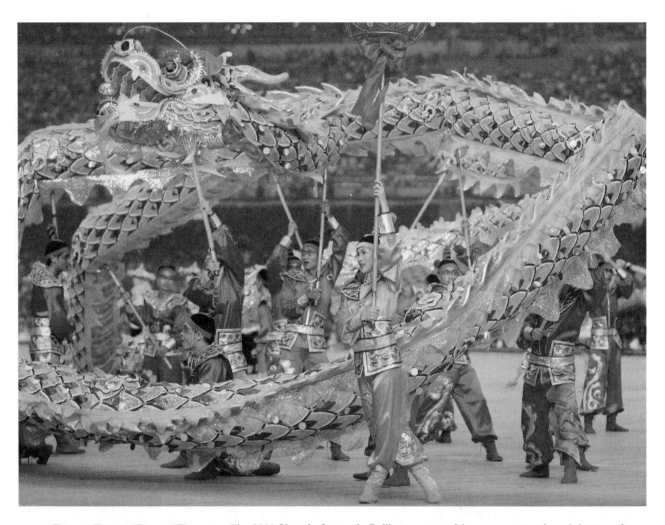

2008

The 2008 **Olympic Games in Beijing** saw one of the most spectacular exhibitions of national artistry in the history of the athletic competitions. Thousands performed in a variety of ways, including traditional dragon dancers like the one shown here in the Game's main stadium. The Golden dragon swirled swayed through the stadium operated by a phalanx of pole manipulators that created the beast's fierce, but graceful movements.

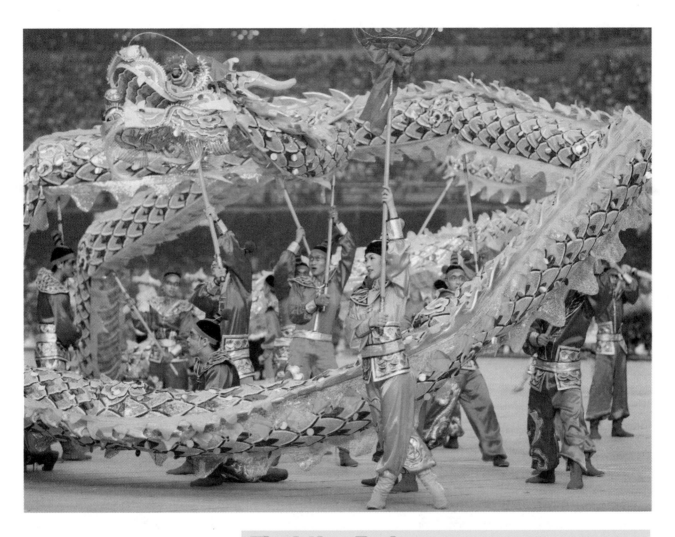

Find the 5 changes see page 110

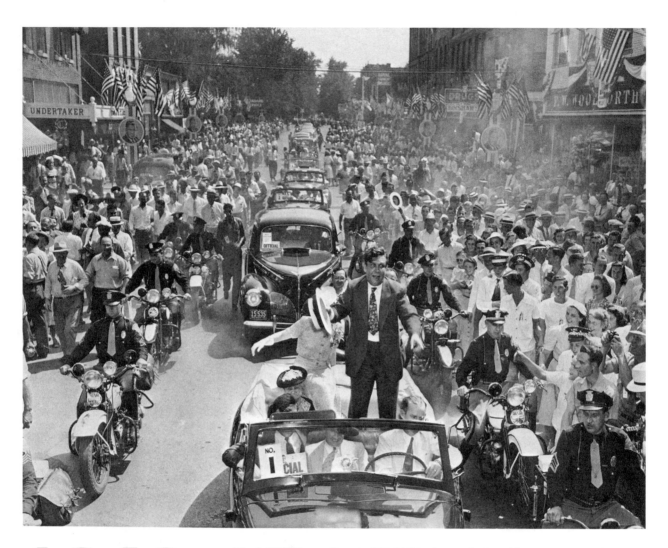

1940

Wendell Willkie, on the eve of World War II, won the Republican nomination for president and campaigned against incumbent president Franklin Roosevelt in 1940. In this picture, Willkie shows his vigorous campaign style en route to making his nomination acceptance speech in his hometown of Elwood, Indiana. His rousing style of speech made Willkie an interesting candidate, but he was no match for Roosevelt's eloquence.

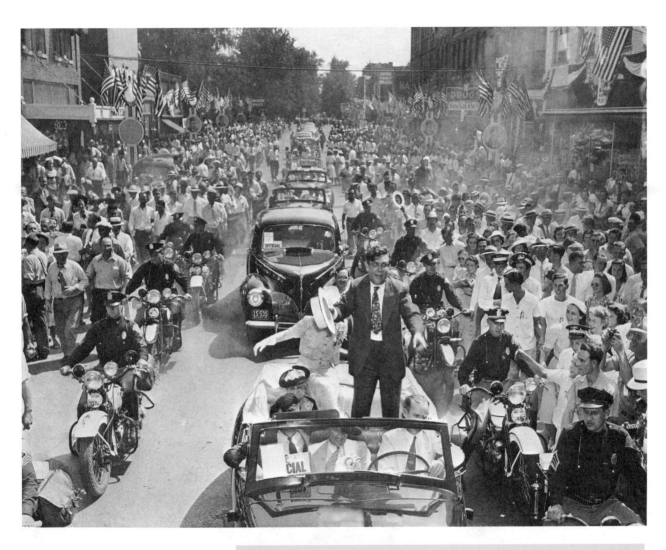

Find the 9 changes see page 111

1970

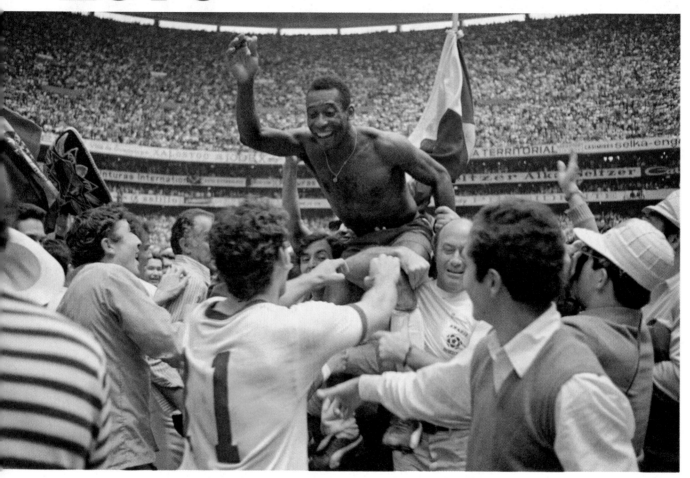

Brazil's Pelé was considered the best soccer player of his time—perhaps of all time. In 1970, Pelé led Brazil to a World Cup championship in Mexico City by beating Italy 4-1 in the final. After an amazing performance, his teammates carried him off the field. It would be his last World Cup

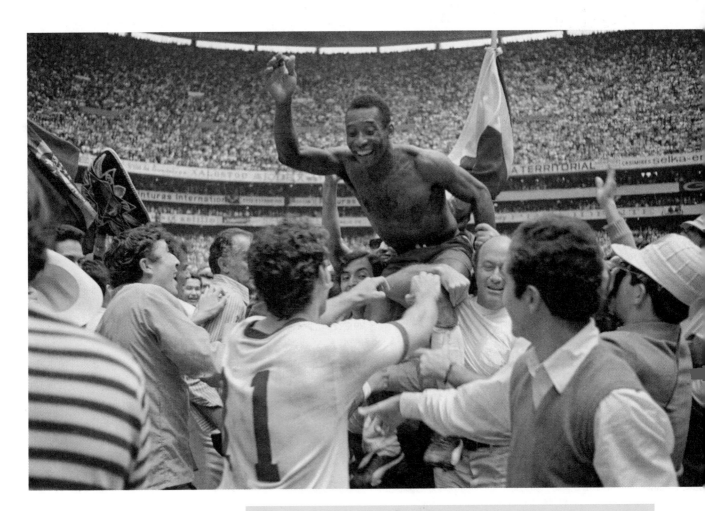

Find the 5 changes see page 111

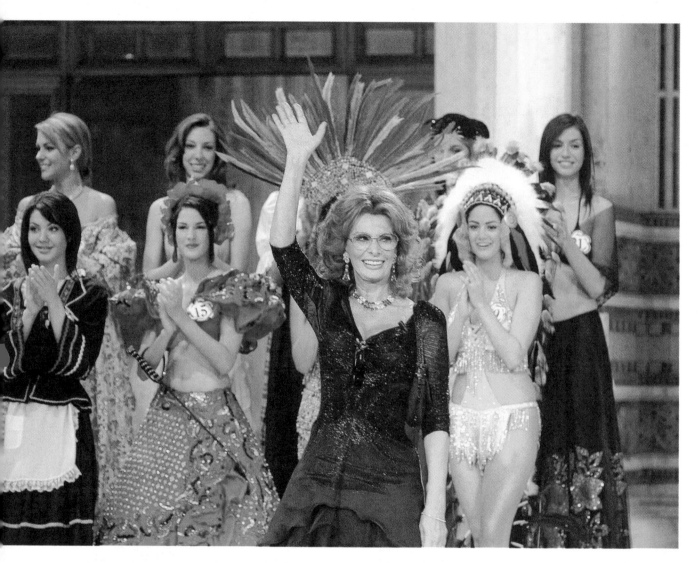

2004

As glamorous as ever, **Sophia Loren** visits a beauty contest in Italy in 2004. Here she poses with the contestants as part of the promotional activities.

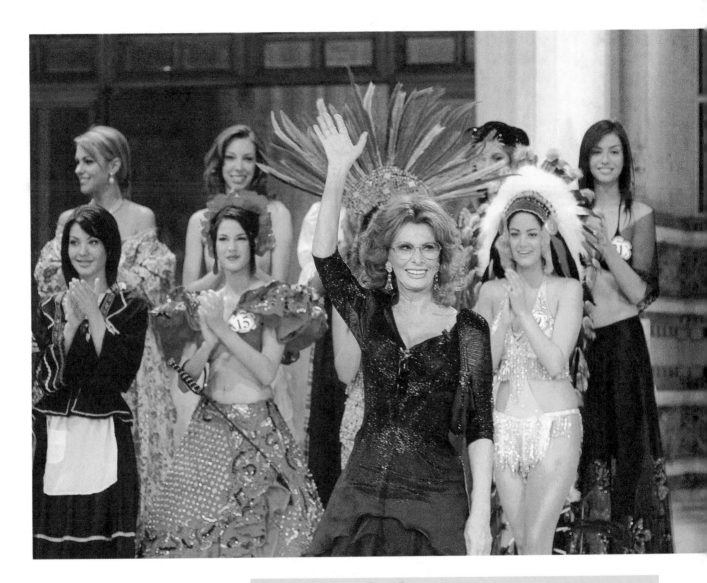

Find the 6 changes see page 111

1917

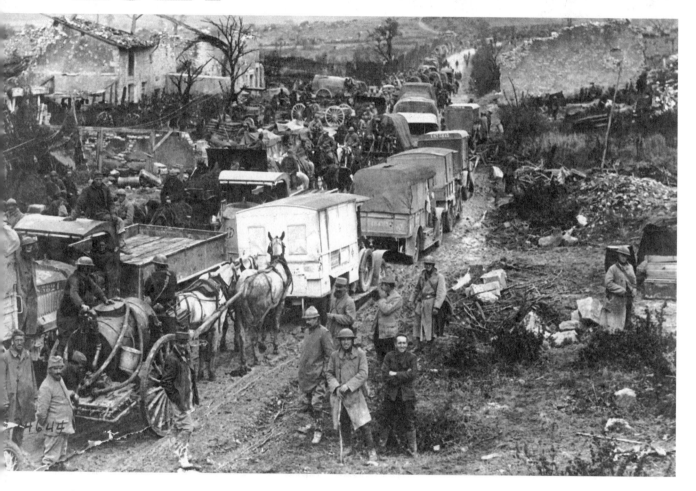

Modern weaponry and transportation gradually became a reality early in **World War I**. But the changes were not instant. Horse drawn carts and wagons often shared highways with trucks and other motorized vehicles. Muddy roads snarled troop and material movement often limiting progress to two miles a day. This scene in the Argonne, a hilly, woody region of France, was not unusual.

Find the 7 changes see page 111

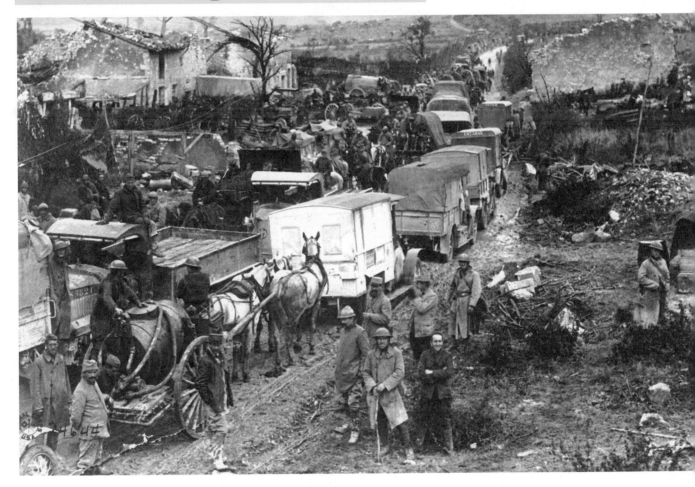

1944

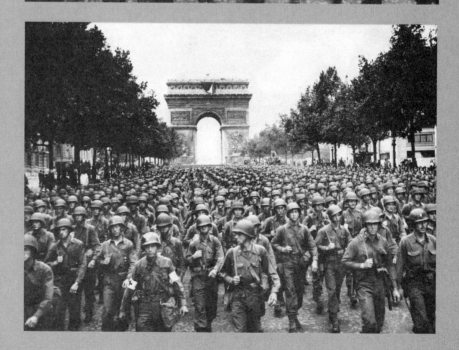

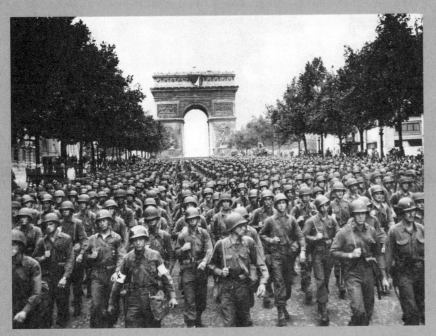

Which is different?
see page 112

American troops parade down the Champs-Élysées in Paris in August 1944, several days after the French capital was liberated. Though the war would last another year, the photo became a symbol of Allied victory in World War II.

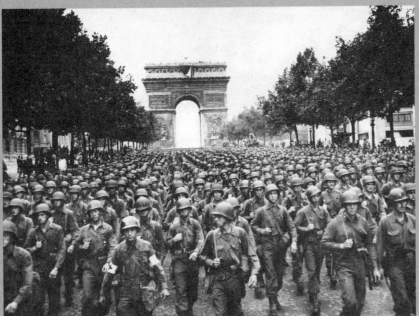

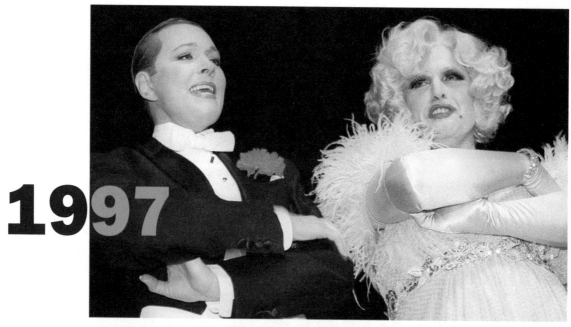

1997

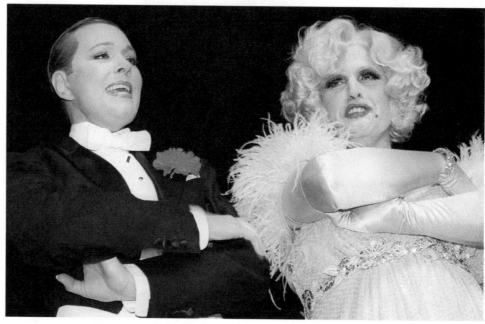

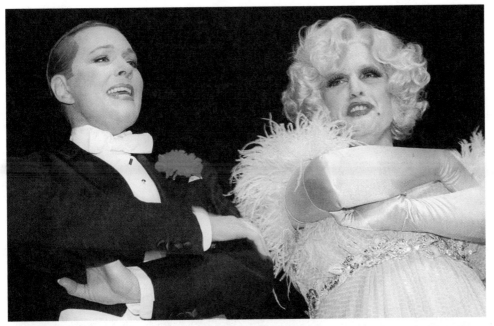

Which is different?
see page 112

Actress **Julie Andrews** and then New York Mayor **Rudy Giuliani**, here dressed in drag, perform at a 1997 press dinner in which satire and witty comebacks flowed like the wine at the tables.

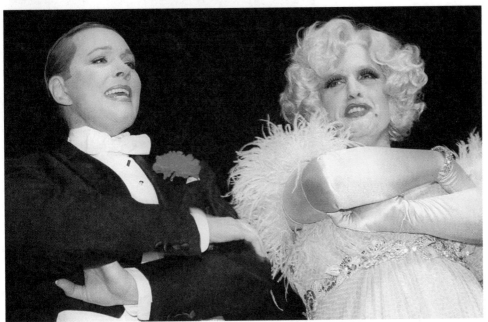

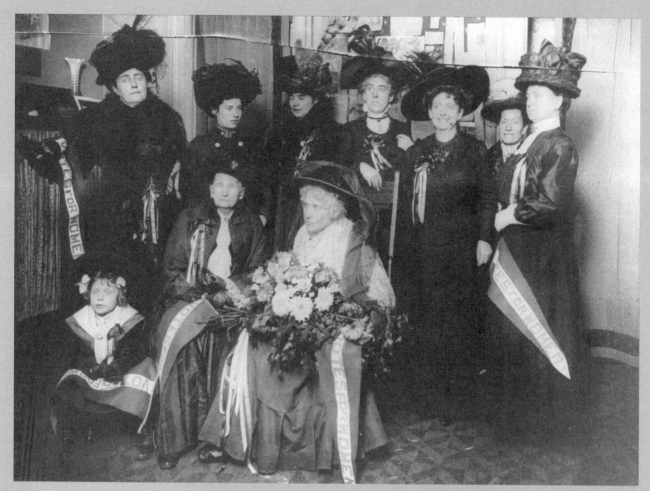

1922

Women of the early 20th century mounted an all-out campaign to win the right to vote in American elections. Known as suffragettes, they formed national and local chapters that marched, spoke, and demonstrated. They were finally rewarded with changes that put them in the voting booth on election day. In this picture **suffragettes** pose for a group portrait after presenting an award to a prominent women's movement leader, Tennessee Celeste Claflin, center.

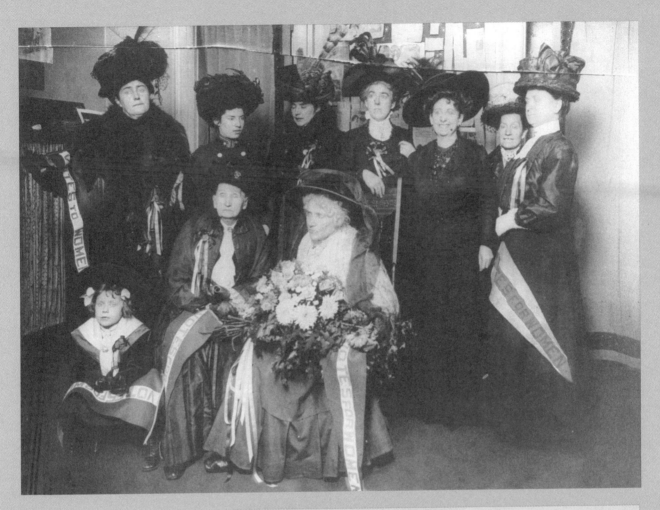

Find the 6 changes see page 112

1909

Which is different? see page 112

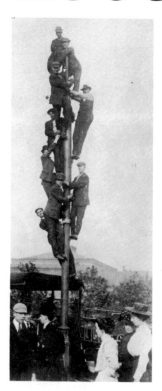 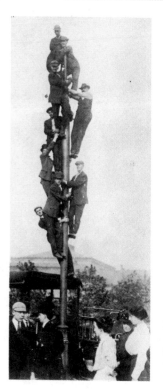 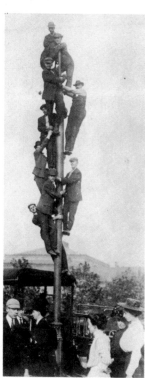 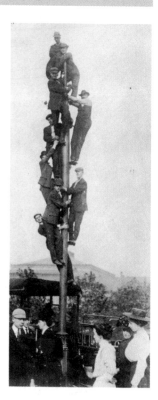

In the old days, circa 1909, a day at the ball park was no picnic. No luxury boxes, no covered stands, no hot dogs and sometimes not even a seat. These **Pittsburgh fans** climbed a pole to watch a game against Detroit.

Which is different? see page 112

1965

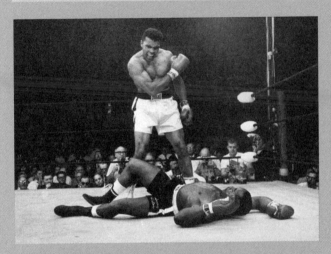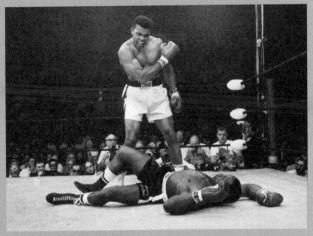

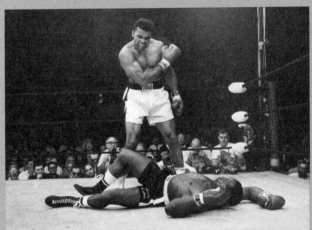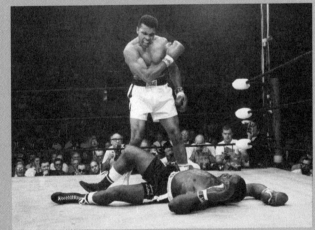

A snarling **Muhammad Ali** stands over the fallen **Sonny Liston**. Ali, the world heavyweight champ, dropped him with a short right to the jaw. "Get up and fight," Ali was quoted as saying, but to no avail. He knocked out challenger Liston in the first round of their title fight in May, 1965 and became the first fighter to win the heavyweight championship three times.

1938

Remember these? They were called **zoot suits**, and were popular in the late 1930s and 1940s. West coast youths were especially fond of the style. In World War II, the suit was banned because it consumed too much material in war shortage America.

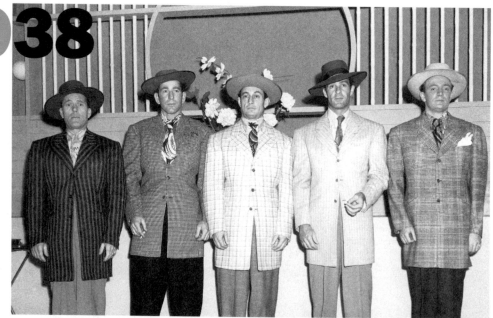

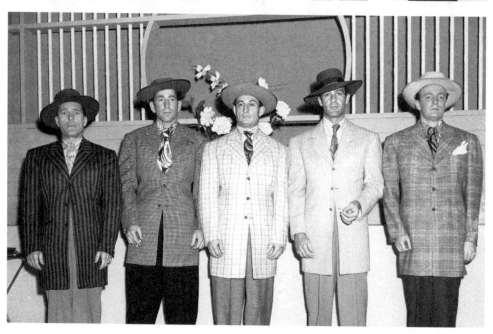

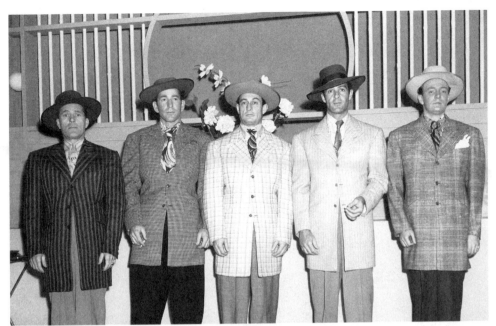

Which is different?
see page 112

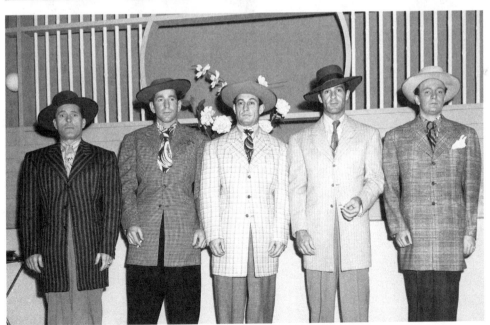

1946

What's wrong? see page 112

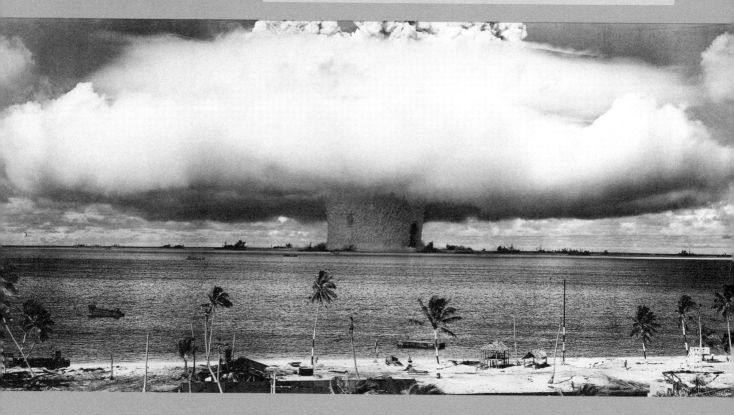

A massive column of water rises from the ocean floor in this 1946 test of atomic power at **Bikini Atoll** in the Pacific Ocean. All personnel was evacuated to ships 100 miles from the bomb site.

Answers

Page 6, Inauguration

This is the real photo of Barack Obama's inauguration. The picture on page 6 shows Abe Lincoln sitting in the crowd, listening to Obama address the throng.

Page 7, Nuremberg

The picture on page 7 has a prisoner, familiar enough but long dead, sitting in the upper box. Hmmm, looks like Hitler himself sitting with pals who were all defendants in the Nuremberg war crimes trials.

Page 8–9, Wedding

(1) Decorative gold is missing at left; (2) Man at right lost his pocket kerchief; (3) Little girl misplaced her flowers; (4) Woman at left in pink now has a floor-length gown; (5) Philip forgot his belt; (6) Wall trim becomes red curtain; (7) Girl at right center is in stocking feet; (8) Queen Elizabeth's necklace is gone.

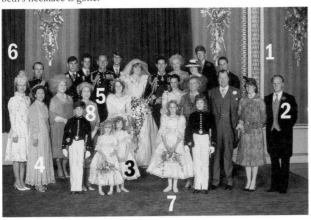

Page 10–11, Parade

(1) Rosy cheeks on the yellow figure in the foreground are gone; (2) Broadway sign is missing; (3) The ad at the upper left lost a model; (4) The vertical frames of the window below the ad vanished; (5) The balloon wearing a green derby changed color; (6) Sign behind yellow-dressed paraders is gone.

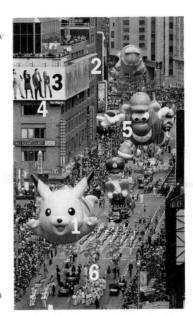

Page 12, Bannister

The different picture of Roger Bannister's finish is at the upper left. The stripes on his shirt are reversed.

Pages 13, Nixon

The sailor on the left is missing his hat. If he really had turned up that way at the ceremonies, he would have been sent unceremoniously to his quarters for disciplinary action.

Page 14, The Beatles

Drummer Ringo Starr's lower cymbal was missing in our altered photo. We left him with only two.

Page 15, Jesse Owens

In this original picture the German athlete on the left makes a Nazi salute which, of course. was put down by Owens's record making athleticism. The picture has become an icon of the futility of the superior race philosophy.

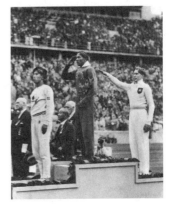

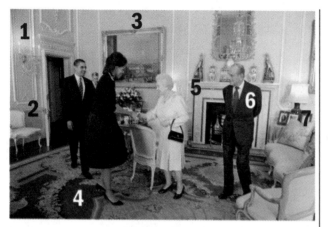

Page 16–17, Obama and Elizabeth

(1) Light removed from fixture near door; (2) Arm rest on chair is gone; (3) Light over painting removed; (4) Decorative figure in carpet missing; (5) Edge trim on fireplace erased; (6) Philip lost his pocket hanky; (7) A picture on the table disappeared.

Page 18, Moon

This is the real picture. What is missing in the photo on page 18 is the reflection on Aldrin's visor of Armstrong taking this picture and the lunar module nearby. Why is that noteworthy? Armstrong was the first to step on the moon. He was also assigned as photographer of the mission. Pictures of Armstrong are fuzzy, blurred images taken by a remote TV camera on the module. The high-quality photographs are of Aldrin, taken by Armstrong.

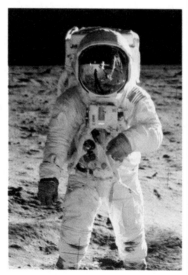

Page 19, Statue of Liberty

This is the correct photo of the Statue of Liberty, formally known as "Liberty Enlightening the World." The puzzle picture on page 19 shows Lady Liberty holding the torch in her left hand. That's incorrect. She holds high the Torch of Liberty in her right hand.

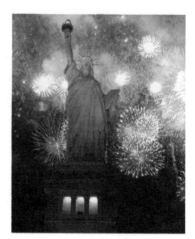

Page 20–21, Bonnie and Clyde

(1) The couple would have trouble running from the cops with the straps of Bonnie's shoes missing; (2) Clyde would not be quite the dapper fellow with his black hatband removed; (3) Fleeing police at night without one headlight would be difficult; (4) A changed license plate, however, would help their escape.

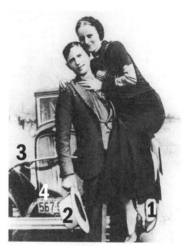

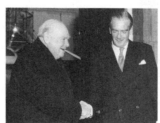

Page 22, Churchill

Winston Churchill was a famous smoker of cigars as this correct photo shows. He seldom, if ever, used cigarettes but he was photographed many times with a cigar in his mouth or in his fingers. At this stage of his life in 1955 he seldom smoked the cigar, but it was usually there, clamped firmly in his teeth, a reminder of old habits.

Page 23, Nixon and Presley

The different photo is positioned at the bottom left of page 23. The date has been removed from the flag on the left.

Pages 24–25, Houdini

All eyes are on the cameraman in this picture, but your eyes should be on the picture at the top of page 25, in which one of the support pillars of the bridge on the right has been removed.

Pages 26–27, Obama

The picture that is altered is in the bottom position on page 27. The police officer just behind Obama's left leg lost his shoulder patch.

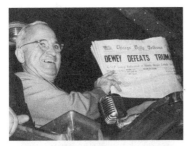

Page 28, Truman

This is the correct picture and now you see why Harry is smiling and displaying the paper. *The Chicago Tribune*, a strong opponent of Truman's candidacy, was certain that Truman's opponent, Tom Dewey, would win...so certain that they produced an edition without the final vote results in hand. Truman actually won the election, and he knew it by the time the Tribune got in his hands.

Page 29, Jennifer Lopez

In our altered picture Jennifer turned up at the awards without a belly button but it is on plain view in this original picture.

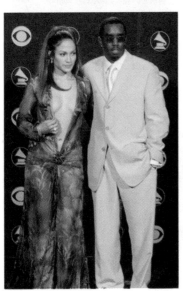

Pages 30, Mardi Gras

The photo at the bottom left of page 30 is slightly different from the others. The decoration has an extra white ball at the right.

Pages 31, Chad

The different chad is on the top right of page 31. Two punch holes next to the judge's forefinger have been removed.

Pages 32–33, Armistice

(1) Soldier lost his flag; (2) Another celebrant lost his hat; (3) Fancy marquee trim is gone; (4) Cobington lost its sign; (5) Window decorations disappeared; (6) That woman must have dropped off.

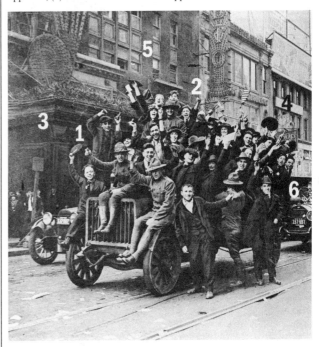

Page 34, Ruth

The Babe loved the cheers of the crowd on his final appearance at Yankee Stadium, but he would not have appreciated the fact that we changed his number. Babe's number was 3, immortal 3, never again worn by a Yankee player.

Page 35, Lindbergh

This is the right picture. What is missing in the photo on page 35 is the name of the plane, Spirit of St. Louis.

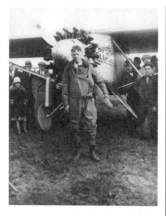

Page 36–37, Custer Civil War

(1) Officer's hat is missing; (2) The tent pole is gone; (3) The bottle is already in the rubbish; (4) Soldier's pipe is gone; (5) Soldier's rank and epaulets are gone; (6) The stool has three legs; (7) The buttons are missing from soldier's jacket; (8) How did that Coca-Cola bottle get there?

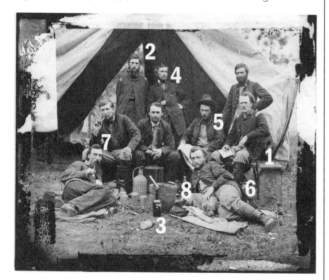

Pages 38–39, Yeltsin

So vigorous was his dancing that he lost his tie clasp, which was removed from the photo at the top of page 39.

Page 40–41, Man and tank

(1) Lights are gone; (2) Tank's aerial has disappeared; (3) Canon is missing; (4) Traffic arrow has been removed; (5) Wheels of third tank are gone.

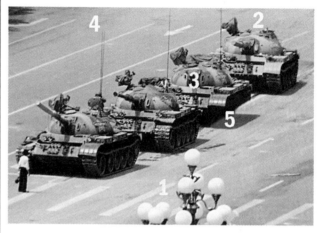

Page 42–43, Clinton and Gore

(1) Floor trim is missing; (2) Clinton's tie turned solid red; (3) A thirsty passerby must have taken the big, green soda bottle; (4) "Drink" sign vanished; (5) The counter stool lost its back; (6) "COMICS" sign was whisked away; (7) Top shelf is sold out.

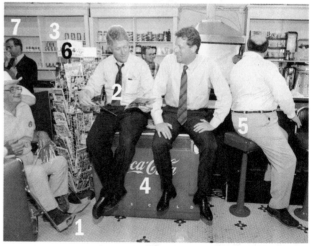

Pages 44–45, Elbe meeting

The different picture of Americans and Russians at the Elbe is at the top of page 44. The GI standing at the left is missing the strap that holds his bag.

Page 46, Kennedy

Kennedy's charm and wit won the day for the Democrats in 1960 but the sign at the upper right in the photo on page 46 says, "Man for the 80s." The real picture looks like this:

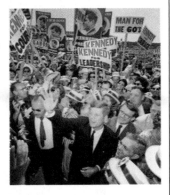

Page 47, Tiger

When in a tournament, Tiger Woods almost always has the Nike Swoosh logo on his hat and shirt, as in this unaltered version of the picture on page 47. Sometimes he subs the Nike logo for his own TW logo, but he never wears a blank cap and shirt.

Pages 48, Gromyko ousted.

The photo of Andrei Gromyko unanimously removed as president marked forthcoming changes in the Soviet Union. The picture at the upper right of page 48 was changed by lowering one hand (upper right), making the vote less than unanimous. If true, the picture would have told a different story.

Page 49, Carrie Nation

If you compare this unaltered picture of Carrie Nation with the picture on page 49, you will see that she preferred the ax shown here to the hammer shown in the incorrect version. Either way, she carried out her mission with extreme zest.

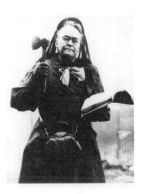

Page 50–51, Golden Spike

(1) Celebrant at right of left smoke stack removed; (2) Top of right smoke stack is gone; (3) Brush at lower right is gone; (4) Man, hands in pocket at left, has disappeared; (5) Another missing man at top left; (6) Locomotive rivets are missing; (7) Smoke stack decoration has disappeared.

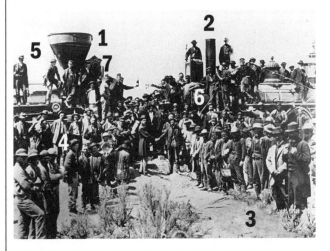

Page 52–53, Yalta

In the photo at the bottom of page 52, we removed the cigarette from the hand of President Roosevelt.

Page 54–55, Hitler

(1) Hitler lost his lapel flower; (2) Hindenburg dropped his cane; (3) The uniformed man lost the belt across his chest; (4) Waving hand is missing; (5) Stripes on his sleeve disappeared; (6) Man in crowd is gone.

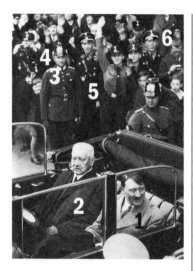

Page 56–57, Castro and Khrushchev

(1) White walls on the car turned dark; (2) The fender flag disappeared; (3) The sign in the back vanished also; (4) One of the security men in the car is gone; (5) The motorcycle rider lost a headlight.

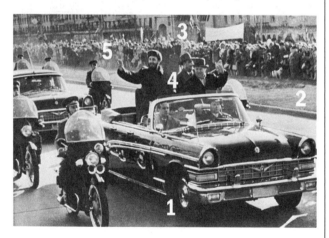

Page 58–59, Bill Veeck

(1) Stripes on socks are gone; (2) Ball is not in catcher's glove; (3) Home plate is missing; (4) Batter's box disappeared; (5) Bat in background is gone.

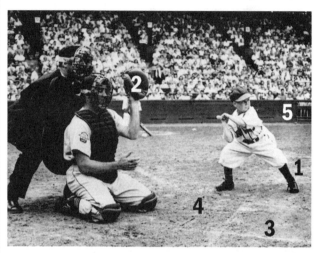

Page 60–61, Berlin Wall

(1) Red jacket is no longer red; (2) Graffiti is gone; (3) Markings on wall of Brandenburg Gate are gone; (4) White jacket is now yellow; (5) Celebrant is missing from wall.

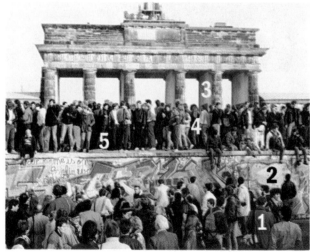

Page 62–63, Prohibition

(1) Lights are out on the marquee; (2) Part of the banner is missing; (3) Hope this barrel doesn't leak since one band is missing; (4) The soda is gone; (5) Coat buttons are missing.

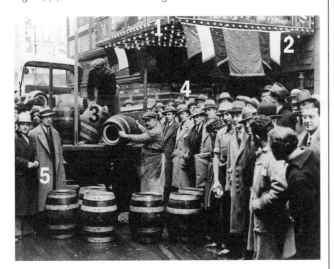

Page 64, Rockettes

The Rockettes are a precision-dancing team, but you would never know it from the picture on page 64. One of the dancers in the middle is out of step. But she didn't really miscue. In this original picture, the Rockettes are in perfect step.

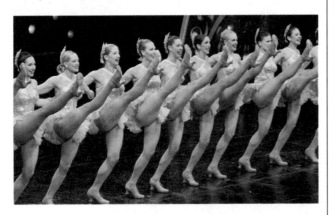

Pages 65, Jackie Robinson

The different picture is at the bottom left. The ump lost his chest protector. Despite Robinson's spectacular base running, the Dodgers lost the game, 6–5.

Page 66–67, Jimmy Stewart

(1) Flying goggles are missing; (2) Someone took the briefcase from the shelf; (3) Stewart's name tag disappeared; (4) Picture on the wall has been removed; (5) Flyer's parachute harness is gone; (6) Table brace vanished; (7) Top shelf was removed.

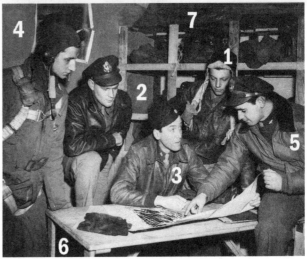

Pages 68–69, Teddy Roosevelt

Check the picture at the bottom of page 69 for the Rough Rider seated third from left. He lost his suspenders.

Pages 70–71, Dillinger

In the picture at the top of page 70, the hand of the man in the dark vest is behind the arm of the woman in front of him.

Page 72–73, Bush

(1) Colors are reversed; (2) Plus sign is gone; (3) Necklace is missing; (4) Collar is yellow; (5) Bush's tie is blue.

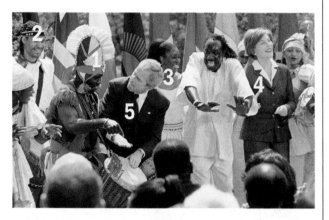

Page 74–75, Times Square Kiss

(1) Foot behind the woman is gone; (2) Store sign is gone; (3) The seams in her stockings are gone; (4) Sailor's kerchief is shortened; (5) Woman has lost her hair clip.

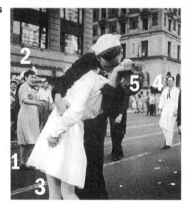

Pages 76–77, Y2K

The different picture among these four is at the top of page 77. The mouse on the blue pad in the center is gone.

Pages 78–79, UN

The different picture is located at the top of page 78 in this sequence. The United States and UK desk identifiers have been switched.

Page 80–81, White House Easter Egg Roll

(1) Woman's white scarf is missing; (2) The tree was trimmed to reveal the White House pillars; (3) The start sign is floating in the air, its stand gone; (4) The fence of the White House balcony is gone; (5) The girl in the pink must have gone home early; (6) The rope to restrain spectators was removed.

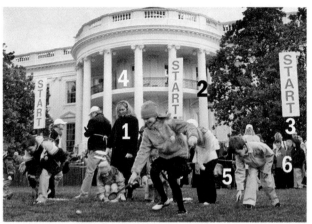

Pages 82–83, Olympic Games in Bejing

(1) The black dot on his nose is missing; (2) His larger silver belt-jacket is gone; (3) A performer has lost his yellow headband; (4) Pants longer; (5) The elegant silver trim disappeared.

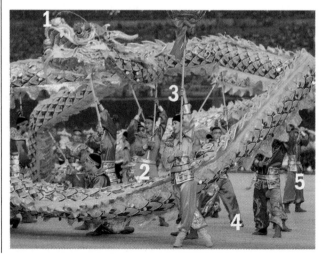